SOUTH YORKSHIRE'S
CINEMAS & THEATRES

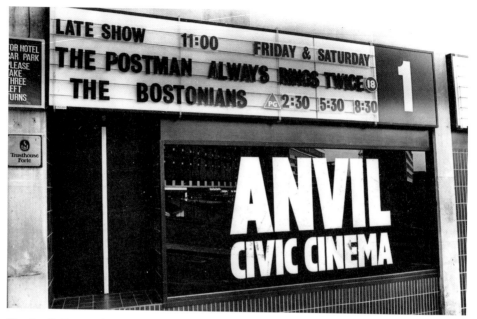

The Anvil Cinema, formerly Cineplex, Charter Square, Sheffield. Picture reproduced courtesy of Sheffield Newspapers.

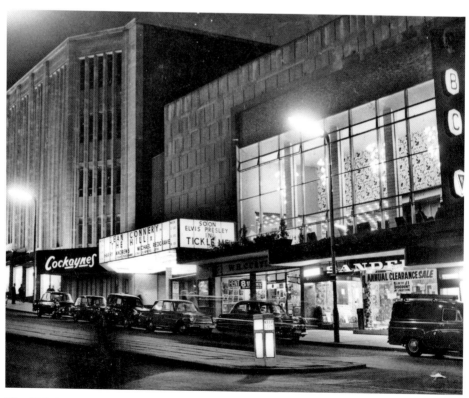

The ABC Cinema, Angel Street, Sheffield. Picture reproduced courtesy of Sheffield Newspapers.

SOUTH YORKSHIRE'S
CINEMAS & THEATRES

PETER TUFFREY

AMBERLEY

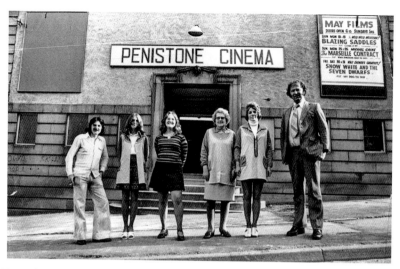

Erected in 1913 and jointly funded by the Urban District Council and the Carnegie Foundation, the Town Hall and Library at Penistone began showing films two years later, under the title of the Town Hall Picture House. For the first fifteen years the films were silent and following extensions during the 1920s the cinema could accommodate 900 people. The first 'talkies' were shown there in October 1930 and despite competition it survived, being continually updated. In the 1960s the stage and bar were added, and it was renamed the Metro Cinema in 1986. Following the installation of a 4/10 Compton organ from the Paramount (now Odeon) in Birmingham in 1999, the Metro was renamed Paramount. Penistone cinema and workers are seen here on 24 May 1975.

Acknowledgements

I would like to thank the following people for their help: Christine Evans (Rotherham Local History Librarian), Paul License, Duncan Mangham, Hugh Parkin, Richard Roper, Jane Salt, Colin Sutton, Tristram Tuffrey.

Special thanks are due to Richard Roper for reading through the proofs.

First published 2011

Amberley Publishing
The Hill, Stroud
Gloucestershire, GL5 4EP
www.amberleybooks.com

Copyright © Peter Tuffrey, 2011

The right of Peter Tuffrey to be identified as the Author of this work has been asserted in accordance with the Copyrights, Designs and Patents Act 1988.

ISBN 978-1-4456-0577-7

British Library Cataloguing in Publication Data. A catalogue record for this book is available from the British Library.

Typeset in 10pt on 12pt Sabon. Typesetting by Amberley Publishing. Printed in the UK.

Contents

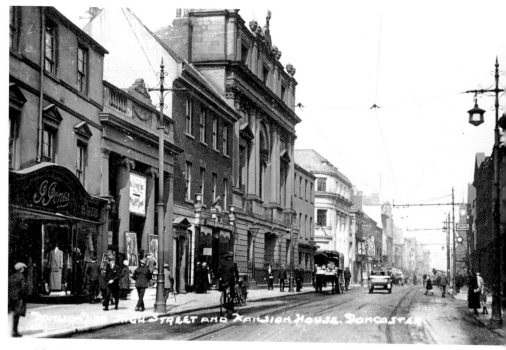

The Cinema House/Savoy (on left), High Street, Doncaster.

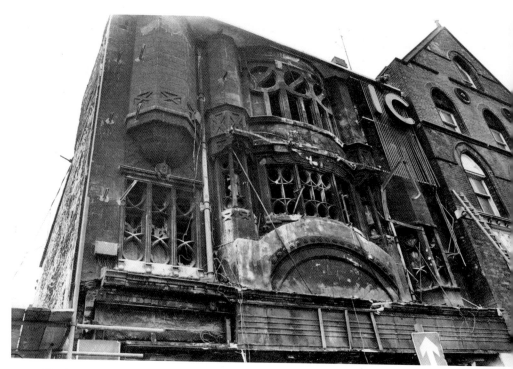

Classic Cinema, Fitzalan Square, Sheffield, pictured after the fire on 24 February 1984. Photograph reproduced courtesy of Sheffield Newspapers.

Introduction

I feel sad when looking at old surviving cinema buildings. They have become ugly, disfigured structures in a street or landscape. The colossal buildings that were erected at the height of cinema era in the 1920s and 1930s struggle for an alternative use and they are the ones, unfortunately, that stick out the most. Yet, who at that time could have predicted that 'going to the flicks' would be rapidly superseded by television? In a way, a comparison may be made with railway stations, particularly those serving branch lines. Many of these were quickly made redundant by the introduction of motorised transport. Numerous railway stations and cinemas/theatres only had a comparatively short lifespan when compared with other buildings and it is fascinating to look back at them in their prime. So having produced *South Yorkshire Railway Stations* for Amberley Publishing, I am pleased to offer this present book on South Yorkshire's cinemas and theatres.

For the most part, the showing of films in the main areas of South Yorkshire followed a pattern. They were largely introduced in theatres or music halls during the 1890s as part of a live entertainment programme. The growth of the industry during the first decade of the twentieth century led in many cases to theatres switching to films full time, although some continued with occasional live shows.

In South Yorkshire, particularly in the outlying districts of Barnsley, Doncaster, Rotherham and Sheffield, where industry was rampant, particularly coal mining, there was a great need for entertainment. Therefore, it was only natural that the new film industry should spawn purpose-built cinemas across the entire South Yorkshire area. Small limited companies were established by local entrepreneurs to run these and several local building companies and architects found much work. The use of white faience on neoclassical and Moorish revival-style frontages was extremely popular and could be found in many areas, though unfortunately few have survived intact today.

As the 'talkies' were introduced in the late 1920s and early 1930s, many cinemas were refurbished to accommodate the new equipment and provide patrons with as much comfort as possible. This also sparked a desire to create new, colossal super cinemas in a second wave of cinema building. Many of these could seat up

to 2,000, whereas those built in the first wave accommodated on average around 900.

In a period where health and safety was almost non-existent, it is a pleasure to recall that no major loss of life occurred in any of the region's cinemas. This is apart from the tragedy at Barnsley Civic Hall, and not forgetting that quite a number of cinemas and theatres suffered fire damage, albeit with no customers present at the time.

Although theatre-going declined with the upsurge in the cinema craze, I am pleased to mention that live theatre is still very much alive in all four of the regions included here. It is particularly evident at Sheffield's Lyceum and Crucible theatres, not forgetting the Paramount at Penistone, the Dearne at Goldthorpe and the Civic at Rotherham. At the time of writing a new theatre is in the course of construction at Doncaster.

Many cinemas and theatres in the late 1950s and early 1960s started introducing bingo part-time, and then full-time. Sometimes this was a success, but not many survive as bingo venues today and so full-scale demolition has taken place. A small number of cinemas have found use as snooker halls, but conjuring up a use for a large hall with all the attendant maintenance and safety issues has been a major problem and continues to be so for those still hanging on to survival. Fortunately, a few have gained listed status, to remind us of the former halcyon days of the cinema.

My interest in cinemas came about through meeting Richard Ward, author of *In Memory of Sheffield's Cinemas* (1988). Richard asked me to help him with the research and be joint author on that project, but being too engrossed at the time with my Doncaster books I declined. I also talked with Ron Curry about helping him to produce *Let's Go to the Pictures: Illustrated History of the Picture Houses of Doncaster* (1987), but nothing came of that either. So, some twenty years later, after talks with both these authors, I am pleased to produce a book bringing together information and pictures on not only Sheffield and Doncaster's cinemas and theatres, but those of Barnsley and Rotherham too.

Thanks should also be expressed to Colin Sutton, who has produced a masterly website on the history of Rotherham Cinemas and theatres, and also to Richard Roper, who is a regular contributor to the Cinema Treasures website and anything else cinema-related. Christine Evans and her staff at Rotherham Archives and Local Studies Library should also be mentioned. My son Tristram, as always, provided much-needed assistance throughout the course of the project.

Barnsley

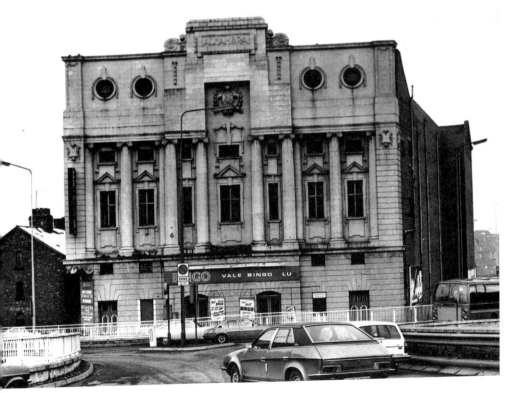

Alhambra Theatre, Doncaster Road, Barnsley
Built to the designs of architect P. A. Hinchcliff, the Alhambra Theatre was opened on 1 October 1915 by Wentworth Woodhouse's Countess Fitzwilliam for the theatre's owners, the Alhambra Theatre (Barnsley) Ltd. Initially seating 2,362 in the stalls and three balconies, this was reduced to 2,100 in 1939: 826 in the stalls, 325 in the first circle and 449 in the upper circle; the top balcony was closed off. The photograph was taken on 24 February 1981 and is reproduced by courtesy of Sheffield Newspapers.

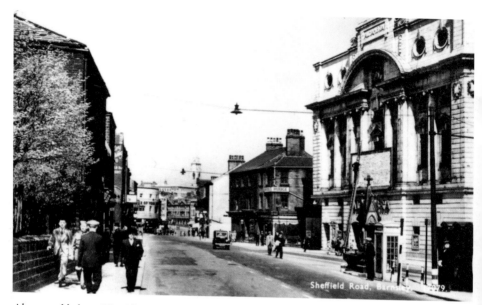

Above and below: The Alhambra supported live theatre until 6 June 1925, when it was converted to a cinema. Five years later, Federated Estates of Regent Street, London, acquired the cinema and installed Western Electric sound. Odeon Theatres Ltd took over the Alhambra Theatre on 5 June 1938, but it was fortunate enough to retain the Alhambra name. Later, it passed to the Rank Organisation, and was closed on 26 November 1960 with a film from John Osborne's play *The Entertainer*. In 1968 it reopened as a Top Rank Bingo Club seating around 2,000, and then became the Vale Bingo Club before closure again in 1979. Plans to reopen the building as a repertory theatre failed and sadly the Alhambra was demolished in 1982. A shopping centre built on the former site is called the Alhambra Centre. The bottom picture is reproduced courtesy of Sheffield Newspapers and was taken on 29 May 1975.

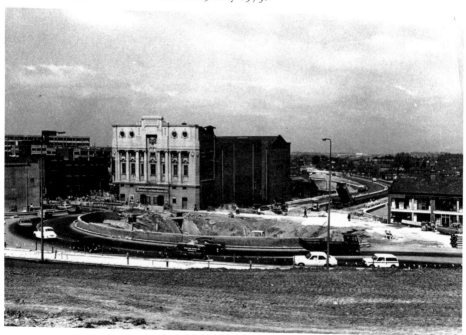

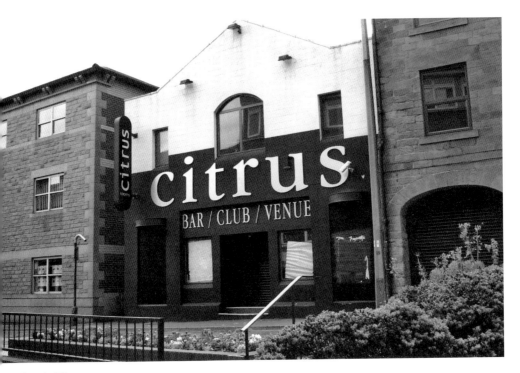

Electric Theatre

Purpose-built as a cinema by London & General Electric Theatres, the Barnsley Electric Theatre opened on 11 March 1911 with an 18-foot-wide proscenium. Its Cinematograph Licence was not renewed in 1938, and in later years it was used by Barnsley College of Technology as a gym and exam centre, a drama facility (the Electric Theatre Studios) and latterly as a bar for students at the College of Art. It was converted to a nightclub – the Citrus Rooms – in 2002. The photograph was taken on 7 August 2011.

Empire, Eldon Street

The Empire Palace of Varieties, designed by North & Robins for the Barnsley Empire Palace Co., was built at a cost of £17,500 and opened on 8 June 1908. Seating 2,500 in stalls, circle and gallery, it also boasted twelve dressing rooms. The axe fell on live shows on 7 February 1920 and the premises reopened as the Empire Super Cinema on 22 March 1920. New Century Pictures were the proprietors and the premises had seating for 1,160. *The Cambric Mask* was the first film to be shown. Later, the Empire was taken over by Provincial Cinematograph Theatres, and in March 1928 by the Denman/Gaumont group. The first 'talkie' was screened on 25 November 1929. Falling under the ownership of J. Arthur Rank's Circuits Management Association, the Empire was renamed the Gaumont Cinema on 13 May 1950. Ironically, after undergoing modernisation in 1953, the building was gutted by a fire in the early hours of Saturday 2 January 1954.

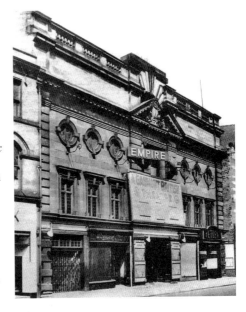

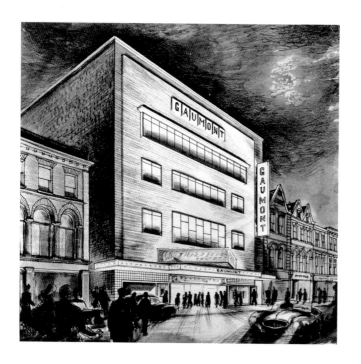

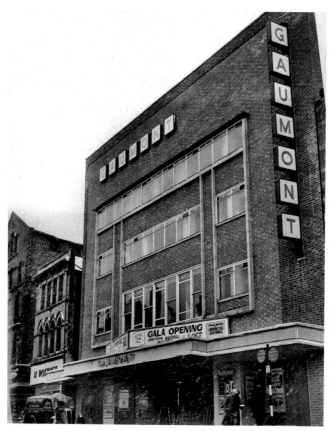

Gaumont, Eldon Street
Designed by T. P. Bennett &
Son, the Gaumont opened in
February 1956, seating 706
in the stalls and 532 in the
circle. It was renamed Odeon
in 1962, twinned at a cost of
around £200,000 in 1980 (one
cinema with a capacity of 600,
the other with 400), and closed
on 17 September 2005. Two
years later it was taken over
by an independent company,
and reopened as the Parkway
Cinema on 8 August 2007.

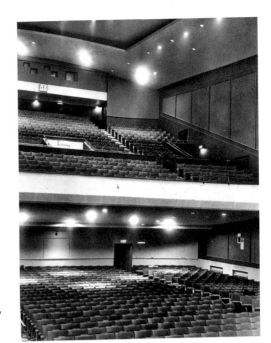

A general view of the Gaumont stalls and circle, 22 February 1956. Reproduced courtesy of Sheffield Newspapers.

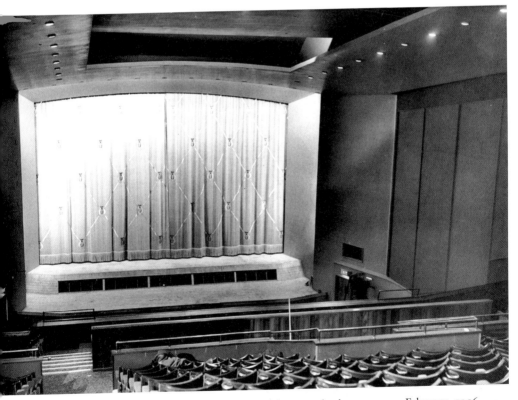

View looking from the back of the Gaumont circle towards the stage, 22 February 1956. Reproduced courtesy of Sheffield Newspapers.

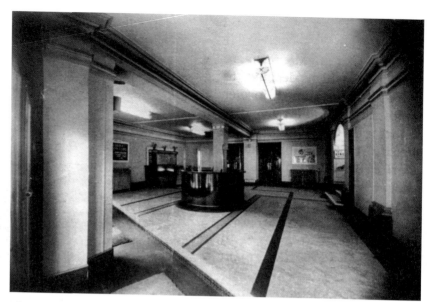

The Gaumont entrance foyer.

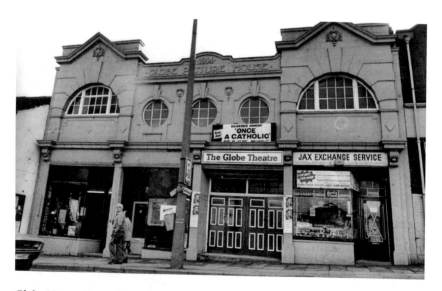

Globe Picture House, New Street

The Globe Picture House, owned by the Globe Picture House (Barnsley) Ltd, was opened at the beginning of September 1914. The first 'talkie', *Kitty*, was shown in November 1929. With a 25-foot-wide proscenium, the Globe originally seated 1,000 on two levels, but later was listed as having 872 seats. Between 1960 and 1962, the Globe went from part-time to full time bingo. *Nymphettes* and *Infidelity* were the last films screened, on Wednesday 20 June 1962. South Yorkshire County Council compulsorily purchased the building during the 1980s for a proposed Western relief road, yet a temporary reprieve allowed usage by the Barnsley Theatre Trust, the Barnsley Playgoers' Society, the Barnsley Junior Operatic Society and the Barnsley Children's Theatre Group. Closure came on 7 April 1990 and the building was demolished. Reproduced courtesy of Sheffield Newspapers.

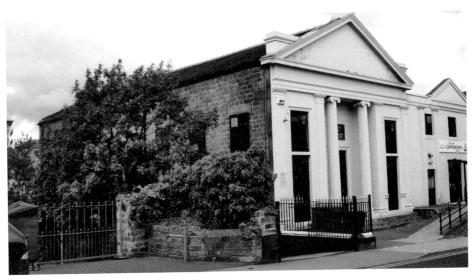

Oddfellows Hall/Temperance Hall/Cosy Cinema, Pitt Street
Dating from the 1830s, the hall began showing films in 1910. It was run by a company named Royal Canadian Motion Pictures. The building eventually became known as the Cosy and closed as a cinema on 28 May 1928; the final films screened were *Flower of the Forest* and *Yellow Menace*. The photograph was taken on 7 August 2011.

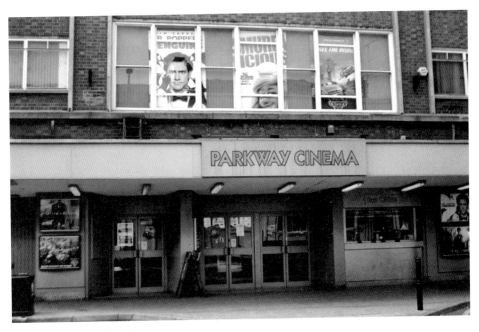

Parkway Cinema, Eldon Street
Rob Younger of Propix Limited (a cinema engineering company) joined forces with Gerald Parkes of Parkway Entertainment Company Limited (cinema proprietors) to reopen the Odeon in 2007, now named the Parkway Cinema. Rob and Gerald both have previous connections to cinema in Barnsley: Rob started his career at the Odeon as a projectionist and Gerald did a spell in the same capacity at the Ritz. The photograph was taken on 7 August 2011.

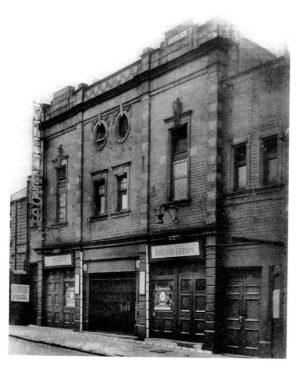

Princess Palace, Racecommon Road
Opening on 19 December in the converted Princess Hall, the Princess Palace seated 850. New Century Pictures Ltd took over in 1913, and by 1929 the cinema was controlled by the Denman Picture House Co. (a subsidiary of Gaumont). The Princess Palace closed on 29 September 1956.

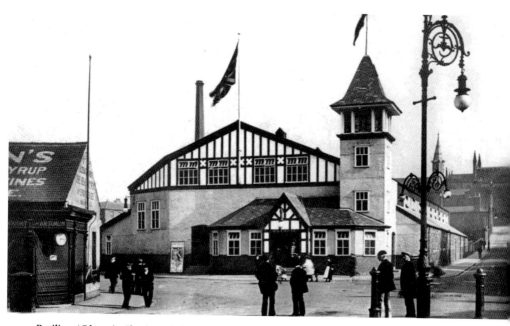

Pavilion (Olympia Skating Rink)
The Olympia roller skating rink was opened on 20 August 1909, but the building became a cinema, under the name of Pavilion, in December 1911. Owned at one time by Mid-Yorkshire Entertainments of Leeds, the last films shown before the building was gutted by fire on 26 September 1950 were *Night and the City* and *The Winner's Circle*.

Ritz/ABC Cinema, Peel Street
Designed by Verity & Beverley (who were assisted by Union Cinemas' 'in-house' architect, Ernest F. Tulley), the Ritz Cinema opened on 22 March 1937, having a white stone frontage with a stepped outline. 'RITZ' was displayed on a double-sided vertical sign and Union Cinemas' name was mounted in large illuminated letters on top. A Wurlitzer 3 Manual/7 Rank theatre organ was installed four days after the cinema opened and Trevor Willetts was the resident organist from 1943 to 1962. A private buyer acquired the organ in 1969.

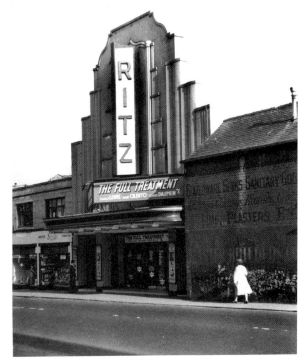

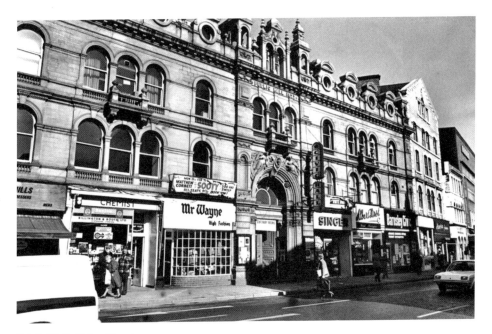

Public Hall, Eldon Street
Dating from 1878, the building started showing films from around 1907. A year later, sixteen children were killed in an accident at the hall while waiting to gain entry for a matinee. In subsequent years films have been screened on an irregular basis. The photograph was taken on 26 March 1980 and is reproduced courtesy of Sheffield Newspapers.

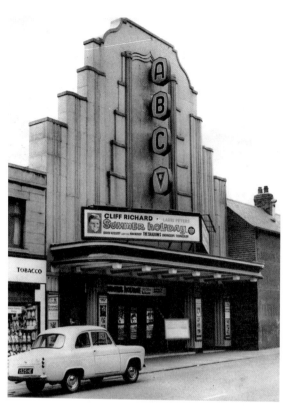

The Ritz was renamed ABC in 1961
(Associated British Cinemas had taken
over Union Cinemas in October 1937).
The cinema closed on 16 March 1974;
Holiday on the Buses was the last
film shown before the building was
demolished.

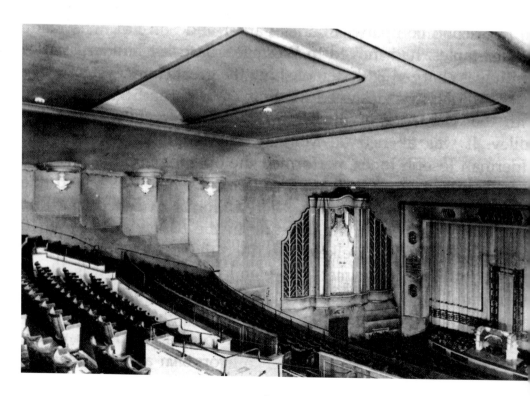

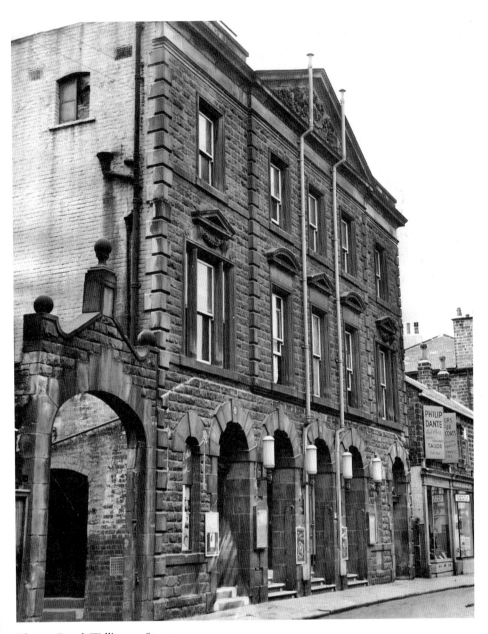

Theatre Royal, Wellington Street

The Theatre Royal is a Grade II listed building and was partly built on of the site of an older theatre. The new building was designed by Walter Emden of London, supervised by Herbert Crawshaw. Built in the classical style with rock-faced stone and ashlar dressings, it is a three-storey building with a five-bay façade. Barnsley mayor Thomas Wilkinson officiated at the opening ceremony in December 1898. The original seating capacity was 1,230. On www.theatrestrust.org.uk, it is stated: 'Originally the auditorium ceiling contained Italian figure paintings representing Comedy, Tragedy, Music and Drama in four main panels, and in the other four panels Spring, Summer, Autumn and Winter with floral and other decorations in harmony with the subjects. The central ventilation grille in the ceiling still contains the remains of a sunburner, which has had a primitive electrolier inserted into it in later times.' The photograph was taken on 26 July 1955.

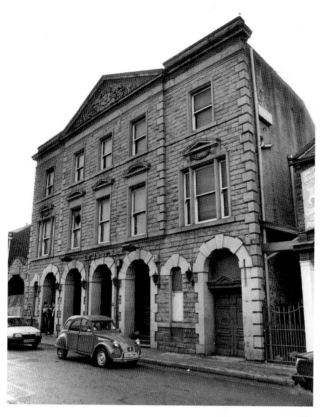

In 1942 the Theatre Royal was altered to the designs of Dyson Cawthorne & Coles after the staging and seated were gutted by fire. The *Sheffield Telegraph* of 26 July 1955 stated: 'In [the twentieth century] it has grown into a well known music hall. Just before the [Second World] war, however, the Denville Players took over for a season of plays ... Barnsley folk will remember a father and son who were managers of the theatre. Popular Mr Albert C. Mitchell was in charge for more than 40 years, and his father held the reins before him for 20 years.' In 1996 the building was converted to a nightclub ('Mustang Sally's'). Both pictures were taken in January 1988 and are reproduced courtesy of Sheffield Newspapers.

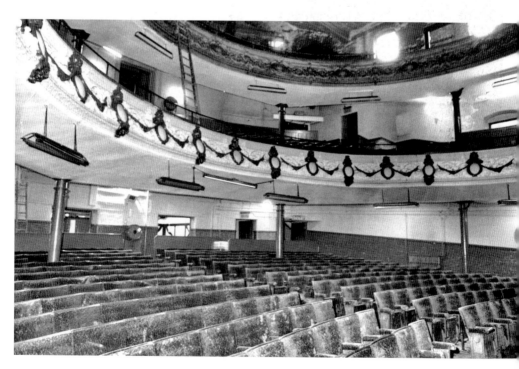

Barnsley District

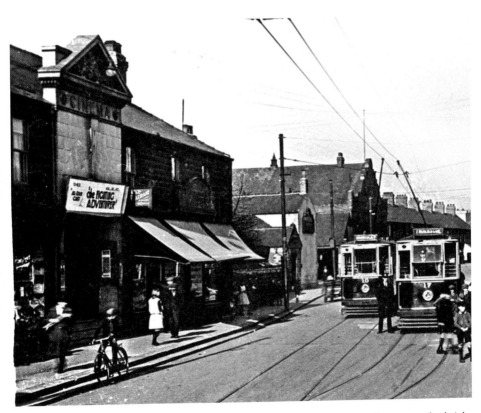

Originally opening as the Hippodrome Theatre, Goldthorpe, on 24 December 1912, the brick-built building was designed by A. Whitaker for owner S. Hamilton and seated 1,000: 450 in the circle and 550 in the stalls. By December 1914 it was in the hands of J. H. Doyle, who renamed it the Picture House on 18 December 1922. A British Acoustic Sound system was installed in 1930, and two years later a lease was drawn up for a Mr E. H. West, who also held Goldthorpe's Empire Cinema.

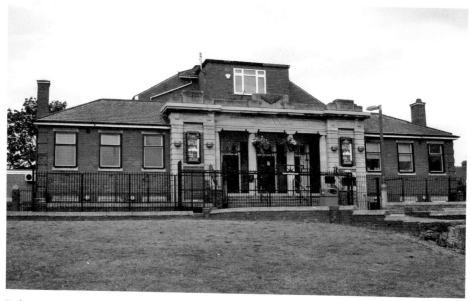

Bolton-on-Dearne, Dearne Playhouse
Known locally for many years as the Welfare Hall, the Dearne Playhouse was given a £1 million renovation, funded by the Arts Council, in 2005. The newly revamped Dearne Playhouse was officially opened on 15 July 2006 by the Dearne's very own Brian Blessed. It has rapidly become the Dearne Valley's leading venue for shows, comedy, concerts, theatre productions, musicals, plays and functions. The photograph was taken on 28 July 2011.

Bolton-on-Dearne, Picture House
On 26 February 1926, this illustration of the Picture House, Bolton-on-Dearne (designed by W. C. Buck), appeared in the *South Yorkshire Times* along with an appeal by Bolton-on-Dearne Limited for prospective shareholders.

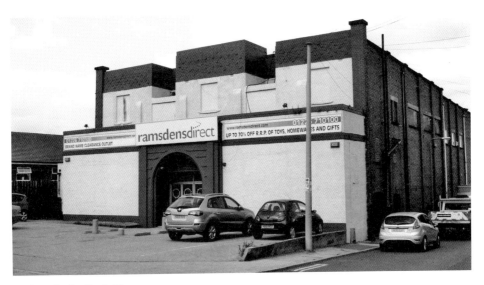

Cudworth, the Rock Cinema

Following closure as a cinema, the Rock became Walker's bingo hall, but is currently occupied by Ramsden's Direct. Talking to the *Independent* on 19 May 1996, celebrated test cricket umpire Dickie Bird stated: 'Even when we weren't playing cricket we were together. Michael [Parkinson] loved film stars – Errol Flynn, Humphrey Bogart, John Wayne – and I'd go with him to the Rock Cinema in Cudworth.' The photograph was taken on 28 July 2011.

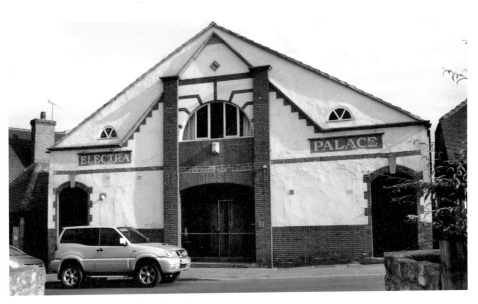

Elsecar, Electra Palace, Hoyland Road

Built by George Longden & Son to the designs of T. Menson Robinson and Percy Roberts, the Electra Palace Theatre opened on 27 August 1912. It seated 600 on a single sloping floor, though by 1930 the seating had been reduced to 450. By the same year talkies had arrived and the cinema went through two name changes in 1938: the Palace in May, and then the Futurist in August. Closure came in 1985 and the building became a club, and then an auction room. The photograph was taken on 28 July 2011.

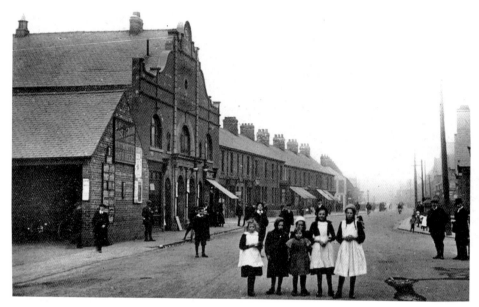

Above and below: **Goldthorpe, Empire Cinema, Doncaster Road**

Designed by Benton & Roberts of Sheffield and built by W. Dunk & Sons of Barnsley for the Goldthorpe Empire Palace Company Ltd, the Empire Cinema opened on 24 December 1910. Seating 800, it was divided into pit and saloon, each of which had their own separate entrances, while the exits were in Whitworth Street, down the side and at the rear of the building. Sound was installed in 1930, and in 1943 the Empire was acquired by Picture House (Goldthorpe) Ltd and the Star Group of Cinemas in 1955. The latter company modernised and redecorated the cinema and bingo was introduced on Mondays only from 17 June 1961. Films continued until 24 June 1972; *Love Story* was the last one screened. The Empire eventually became a supermarket.

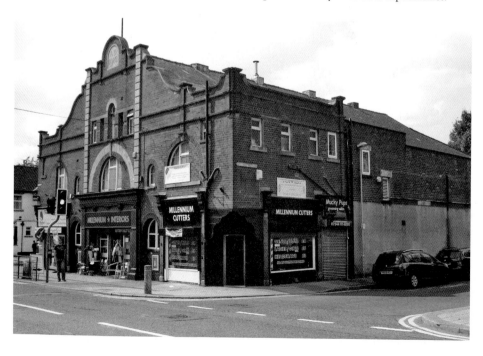

Hippodrome Theatre/Picture House, Doncaster Road

The Picture House became part of the Star Cinema Circuit in 1957, and the last films were shown on 5 January 1963: *101 Dalmatians* and *Kidnapped*. Soon after, the Picture House became a Star Bingo Club, and this stretched until the late 1980s, when it was used as a retail store. The photograph was taken on 28 July 2011.

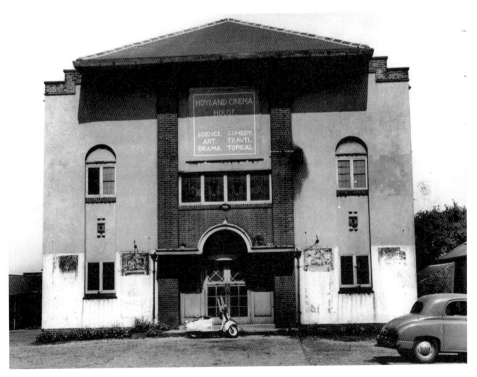

Hoyland, Hoyland Common Cinema House

Hoyland Common Cinema House was built in 1920 and showed its last film in 1957, standing empty until it was demolished in November 1971. The site is occupied by the revived Hoyland Market.

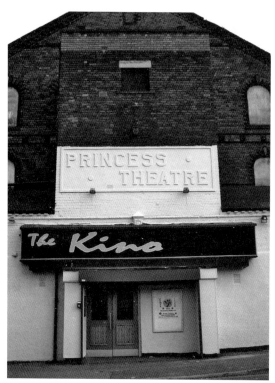

Left and below: **Hoyland, Princess Theatre**
Built by John Parr & Sons, the Princess
Theatre was opened on Boxing Day 1893.
By 1923 the theatre had become a cine
variety house, and also changed its name to
'Kino'. In time, the Kino turned over almost
exclusively to films and showed its last one
during the 1960s. The building became a
bingo hall, and later a snooker hall. The
photograph was taken on 28 July 2011.

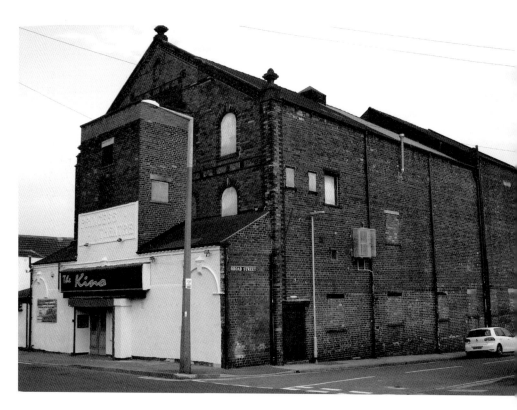

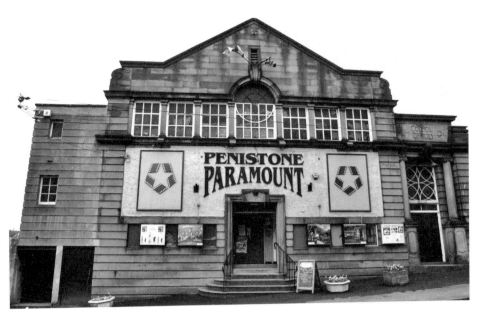

Penistone, Town Hall Picture House/Paramount

The Paramount continues today as a single-screen auditorium, largely devoted to showing films but with occasional live shows and regular organ concerts. Seating 350 in comfort, it retains the atmosphere of the early cinema, albeit with a redesigned proscenium to accommodate cinemascope and stage shows. The Paramount is owned by Barnsley Metropolitan Council and operated by Penistone Town Council. Much work has been undertaken over the years to improve the building, including fitting new seating and providing a bar and up-to-date projection and sound systems.

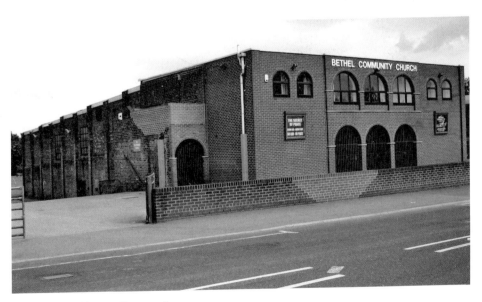

Royston, Ace Cinema, Royston Lane

The Ace Ballroom/Ace Cinema, a substantial brick-built structure, became a dance hall after its cinema days and was then converted into the Bethel Community Church.

Wombwell, Plaza Cinema, Marsh Street

Opening as the Pavilion Skating Rink in 1910, but meeting with little success, the building reopened as the Plaza Cinema on 1 May 1911. The auditorium seated 900 (later reduced to 840) and the first talkie, *Broadway Melody*, was screened on 2 September 1929. Taken over by Wombwell Entertainments Ltd in 1946 and the Star Cinema Group around 1955, the Plaza closed on 8 June 1963 and reopened five days later as the Plaza Casino – Star Bingo & Social Club. But the building returned to full-time cinema use on 28 August 1963, continuing until 12 January 1967, when there was a return to full-time bingo. Enjoying success, bingo continued until the early 1990s, when the building was converted into a snooker club, becoming the Wombwell Snooker & Social Club. The photograph was taken on 28 July 2011.

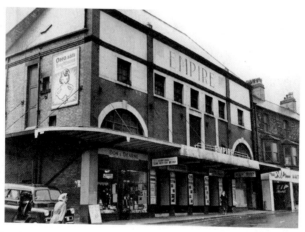

Wombwell, the Empire, Park Street

Opening on 12 May 1910 as a skating rink and a cinema, the Empire Theatre was concentrating solely on films by January 1911. Two years later it was rebuilt as a Variety Theatre, Drama House and Picture Palace. Seating 975, the Empire Theatre was equipped with sound in 1929, opening on Christmas Day with *Fox Movietone Follies of 1929*. The Star Cinema circuit took over the Empire in 1937 and bingo sessions were introduced on certain nights in the week from 7 October 1962. This lasted until 1 December 1962, when films ceased and the building operated as a bingo hall. The local Wombwell Amateur Operatic Society continued to present their yearly productions, though by March 1965 the building had been declared unsafe and beyond repair and was demolished. The photograph was taken on 23 June 1958 and is reproduced courtesy of Sheffield Newspapers.

Doncaster

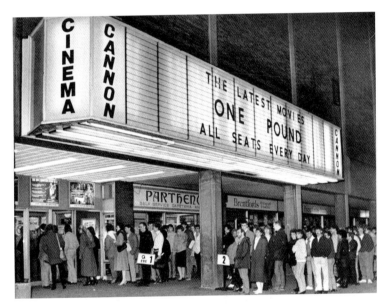

ABC/Cannon, Cleveland Street

Doncaster's new £250,000 ABC cinema – part of the Golden Acres development near the town centre – was opened on 18 May 1967 by the mayor of Doncaster, Councillor G. F. Hardy. The cinema was packed on the first night for the inaugural screening of Carlo Ponti's production of *Dr Zhivago*, starring Omar Sharif, Geraldine Chaplin and Julie Christie. Seating 1,277, the ABC was an outstanding example of the company's confidence in the future of the cinema industry. The Doncaster ABC was the last in a succession of cinemas opened by the circuit, which included Sheffield, Preston, Blackpool, Bristol and Grimsby. The ABC included an underground car park for 250 cars and five shops. The cinema manager was Len Key, who had previously managed the Picture House in the town. The blue-grey brick building carried the illuminated ABC monogram sign running the full height of the design. Associated British Cinemas had been established for twenty-nine years by this time and boasted 267 cinemas. The picture shows the cinema on 19 January 1988 and is reproduced courtesy of Sheffield Newspapers.

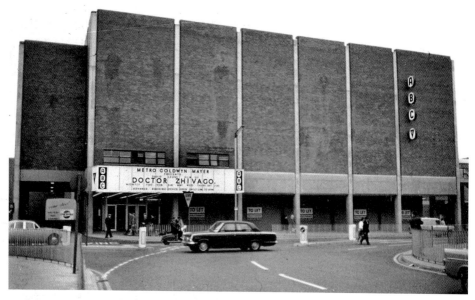

In the mid-1980s the ABC was absorbed by the Cannon Group and was renamed Cannon, closing on 18 June 1992. Since then, the premises have remained empty.

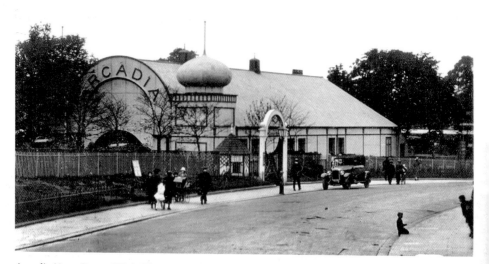

Arcadia/Arts Centre/Civic Theatre, Waterdale

Eric Braim, in the Doncaster Civic Trust Newsletter No. 58, states that in 1921 Harry Russell erected an insubstantial structure in Waterdale for the use of concert parties. It was granted building by-law approval as a temporary building. The building opened in 1922 as the Arcadia and 'in 1931 the Arcadia became a cinema'. The *Don. Chron.* of Thursday 10 February 1949 stated: 'Squads of workmen will on Monday move into the Arcadia Cinema to start the big task of renovating and converting it into the Doncaster Arts Centre. During the five weeks before the opening night, March 21, £6,000 will be spent, but patrons will see little difference. Once inside, however, they will find considerable changes. The whole of the auditorium will have been redecorated, the floor re-covered with rubber, 210 new seats fitted and 410 old ones reconditioned and re-covered.'

Bijou, Market Place

On Christmas Eve 1909 a large building, formerly used as an auction room/skating rink, at the rear of Dolphin chambers in the Market Place, Doncaster, opened its doors as the Bijou Cinema. It became known as the 'Little Hall with the big pictures'. Liverpool's Weisker brothers were the initiators of the Bijou project and a taste of the atmosphere at the Bijou was recalled in the *Don. Chron.* of 14 March 1957: 'Come with me to the old Bijou cinema in the Market Place. It is a lamp-lit room with 300–400 chairs. A piano tinkles in one corner and primitive pictures flicker on the screen.' The last advertisements for the Bijou appeared towards the end of 1922, which is presumed to be the year it closed.

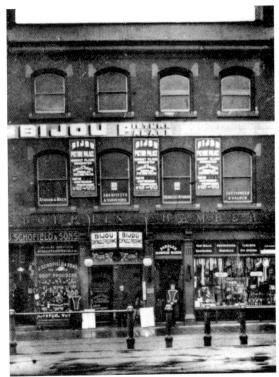

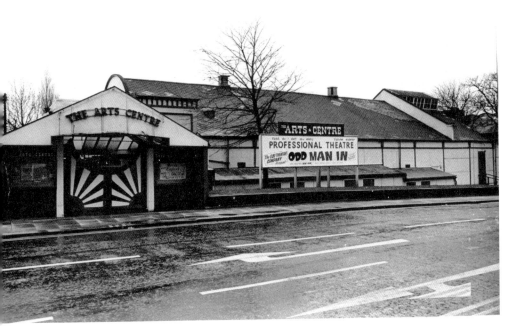

In the mid-1970s the Arts Centre was refurbished and renamed the Civic Theatre. The Civic currently accommodates professional and amateur productions, with an annual pantomime at Christmas.

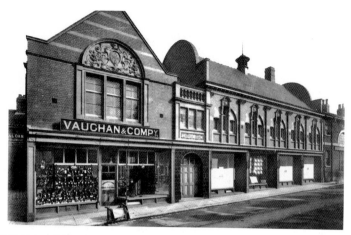

Central Hall, Printing Office Street

Doncaster's first cinema was the Central Hall, in Printing Office Street. A meeting hall adapted as a cinema, it opened on Monday 12 April 1909. The seating, for about 350, was primitive – wooden forms and a few chairs. In February 1911, the following advertisement appeared: 'Central Hall, Remarkable Singing Pictures, These will be shown at each performance.' An attempt was made to synchronise a gramophone record playing with a picture of a female singer. The scheme worked well in rehearsals, but failed dismally when tried on the public. In subsequent years the Central Hall ran into financial difficulties and it closed during April 1923. The building is still there and once housed the outfitting business of John Cliffs.

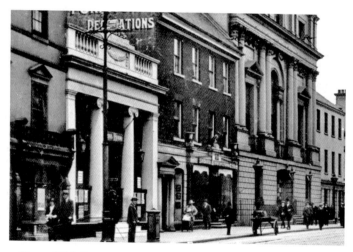

Cinema House/Savoy, High Street

During December 1919, the Old Subscription Rooms, in High Street, were converted into a Cinema House, and the first performances were given on Friday 12 December. It was said that the best features of the building were retained. There was seating accommodation for about 400, with tip-up seats of blue plush. For the opening performance the star was Mary Pickford in *Eagle's Mate*, and in the evening William Russell in *Hobbs in a Hurry*. The Cinema House was the new venture of the proprietors of the High Street Picture House Co. Ltd, whose moving spirit was A. L. Rhodes. Eight years later the Cinema House underwent alterations, reopening as the Savoy. Two brothers named Feldon were the new owners, and they spared no expense on the renovation work. The Savoy survived until around 1930.

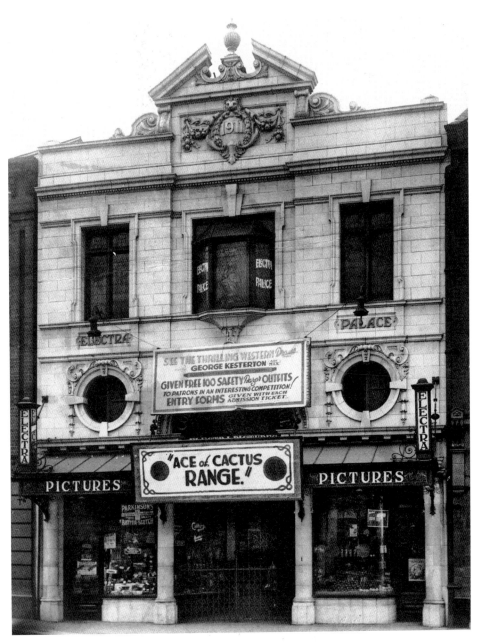

Electra Palace/Regal, French Gate

In December 1911, the *Don. Chron.* stated that the Electra Palace Theatre would open on Thursday 21 December. It was built at a cost of about £3,000 for the Doncaster Electric Theatre Co. Ltd, and boasted a stylised exterior. The material used was eggshell glaze fire clay, supplied by the Leeds Fire Clay Co. The interior seated 700. Appropriate music was to be rendered 'by a small but select orchestra.' Cinematograph machines were installed in duplicate by Pathé Frères. T. H. Johnson of Doncaster designed the building. The general building work was entrusted to Wm Mason & Sons, of Leeds and Doncaster. On 31 July 1931, the *Don. Gaz.* Announced that the Electra was to become the Regal the following day. Extensive alterations had been carried out by T. H. Johnson. *Golden Dawn* was screened at the opening performance.

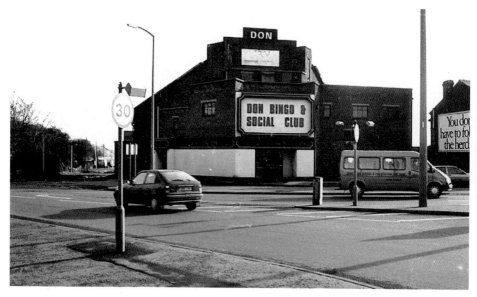

Don, Bentley Road/Great North Road junction

The Don Cinema, near the North Bridge, Doncaster, opened on 17 August 1939 with *The Citadel*. The enterprise was the scheme of J. R. Hebditch and the seats provided for about 1,000 patrons. Henry Barrett & Co. Ltd of Bradford supplied and erected all the steelwork. The sound system employed was the Western Electric Mirrophonic, and the projectors were by Kalee Ltd. The cinema was designed by J. Blythe Richardson. The last film to be shown at the Don was the Beatles' *A Hard Day's Night* on 30 January 1965. The building was subsequently occupied by the Don Bingo and Social Club and was demolished around 1992 for road improvements.

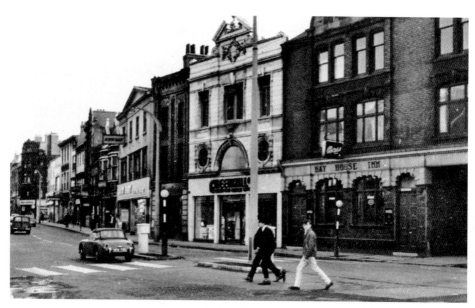

On 9 January 1958, the *Don. Gaz.* reported that the Regal Cinema had been sold to Messrs Greenhills (DYB) Ltd, warehousemen of St James Street, Doncaster. The last films had been screened there some two weeks earlier. It was said the cinema was losing around £10 a week.

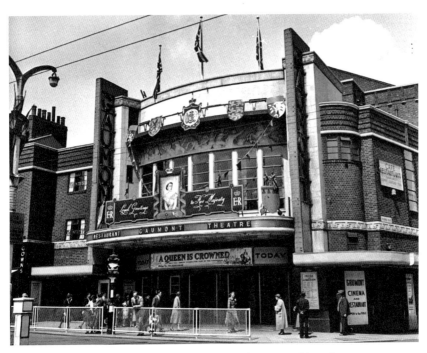

Above and below: Gaumont Palace, Hall Gate/Thorne Road junction

At two o'clock on Monday afternoon, 3 September 1934, the new Gaumont Palace, Doncaster, was opened by the mayor, Councillor G. H. Ranyard. The new manager of the Gaumont was W. Sherwood. The first of many interesting features of the new building was the fine sculptured frieze over the main entrance. The frieze was the work of sculptor Newbury Trent and depicted the growth of a film, from its conception by the author to the writing of the scenario, the building of the set, and, finally, the shooting of the actual scene. In the picture below, taken by Charlie Worsdale in the early 1960s, the Beatles are seen playing at the Gaumont.

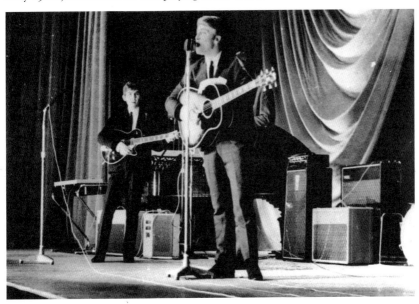

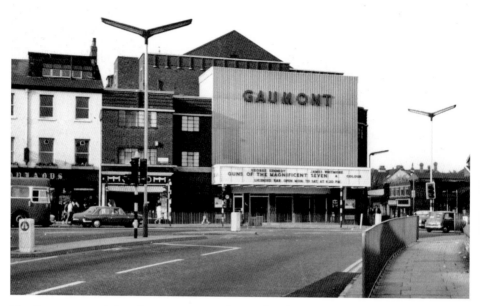

The Gaumont was designed to seat 1,800 and opened with *Evergreen*, starring Jessie Matthews. A feature of the programmes presented was organ recitals on the mighty Compton organ by Hebron Moreland, who came to Doncaster from the Queen's Hall, Newcastle.

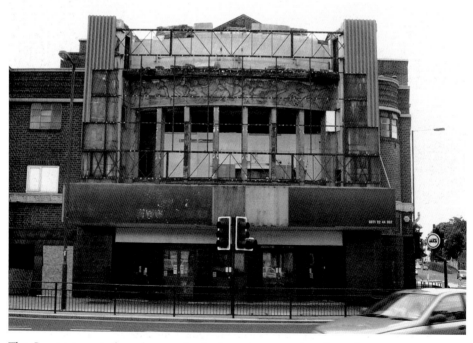

The Gaumont went through a modernisation scheme costing about £80,000 in 1968, was converted in April 1973 to accommodate three smaller cinemas, and was renamed Odeon in January 1987. The Odeon has since closed and was controversially demolished in 2009.

Grand Theatre/Essoldo, Station Road

Built by H. Arnold to the designs of J. P. Briggs, the Grand Theatre opened in 1899 as the New Grand Theatre and Opera House. It prospered as a live theatre, but by 1910 it was screening some films and newsreels as a novelty item on the bill. In the 1914 *Kinematograph Yearbook*, it is listed as a cinema. By 1925 it had gone back to 'live' theatre use and was on the Number 3 touring circuit. It had a 30-foot-deep stage, the proscenium was 30 feet wide and there were ten dressing rooms. In January 1947, the Grand was taken over by the Essoldo chain of cinemas, but remained in 'live' theatre use. The Grand was converted into a cinema and opened on 28 July 1958 using 800 seats in the orchestra stalls only, leaving the two balconies unused. However, the venture was short-lived, as it ended on 19 September 1959.

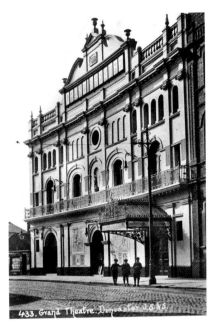

433. Grand Theatre. Doncaster J.S.43.

Local architect F. W. Masters designed and built a circus hall in Station Road, opening in February 1885. It was 112 feet long by 84 feet wide and could hold about 1,700 people. The hall opened with James Clements Boswell's circus, which was attended by about 1,500 people. For two months he produced a weekly programme and, from sixty-four performances, attracted audiences of between 60,000 and 70,000. In 1887, Salvation Army founder General Booth acquired the circus hall and for a few years it became a Salvation Army barracks. This continued until Bosworth's Circus reopened the venue for a season in 1894. The following year local businessman J. W. Chapman took control, renaming it the People's Empire Palace. But in 1898, plans were approved for a new theatre on the site: the Grand Theatre.

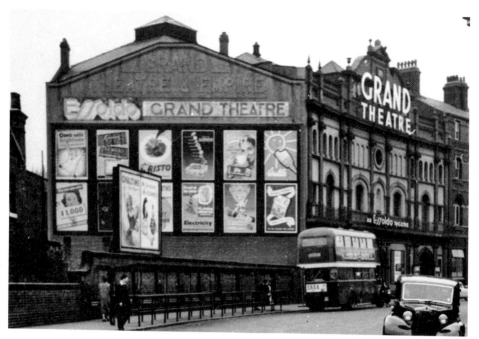

Above and below: The Grand returned to stage theatre use from 21 September until 21 November 1959. The building was closed until 3 September 1961, when it reopened as a bingo hall. The building was given Grade II listed status in 1994 and was then threatened with demolition. Bingo club activities ceased in 1995 and the building now stands empty, awaiting a new use. There is a 'Friends of the Grand Theatre' organisation which is fighting for its survival. A quote on www.theatrestrust.org.uk puts the theatre's present predicament in context: 'It is no longer in a street but on what now looks like the backlot of an inward-looking shopping precinct. It still faces the station but is separated from it by a busy inner ring road which comes so close that it has actually snipped off a lower corner of the stage house.'

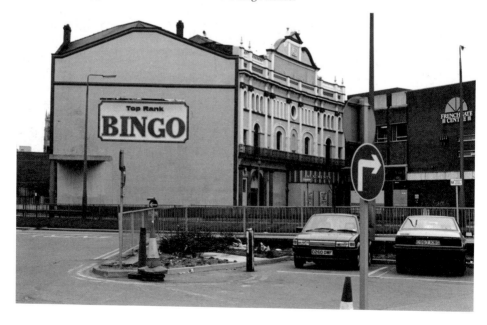

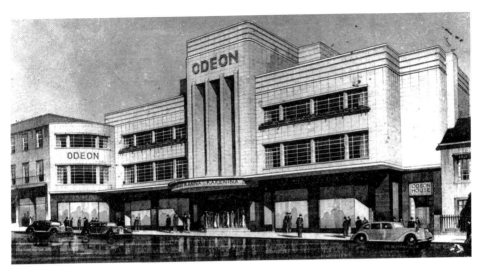

Odeon Cinema, Hall Gate (Proposal)

The *Don. Chron.* of 19 August 1937 announced that work was to begin on the building of the new Odeon Cinema, the site for which had been obtained in Hall Gate, Doncaster, with a frontage of 120 feet. The cost of the scheme was estimated at £60,000. The design was the work of T. Cecil Howitt of Nottingham, who had designed a number of cinemas for Odeon. The man behind all Odeon activities was Oscar Deutsch, managing director of Odeon Theatres Limited. Disappointingly, the cinema never progressed beyond the erection of a steelwork frame and was subsequently abandoned.

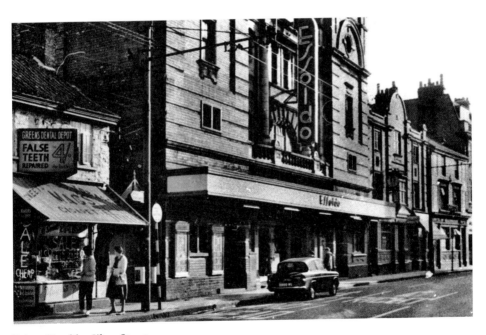

Palace/Essoldo, Silver Street

Designed by Ward & Ball, the Palace Theatre of Varieties opened on 28 August 1911. It was erected by Arnold & Son of Doncaster and the front, on Silver Street, was of red-faced bricks from the Conisbrough kilns, with grey terracotta enrichments.

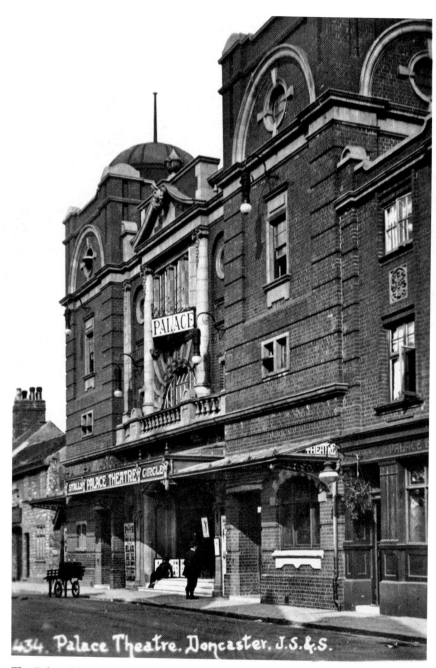

434. Palace Theatre. Doncaster. J.S.&S.

The Palace Theatre thrived until 1920, when it changed over to motion pictures, though films had been shown as part of the programmes since 1914. In 1937 the building underwent considerable alterations and, ten years later, it became known as the Essoldo after being taken over (together with the Grand Theatre, Doncaster) by the Essoldo chain of cinemas. Seven years later, CinemaScope, with full stereophonic sound installation, was introduced and the opening film was *Flight of the White Heron*. The Essoldo survived until 24 November 1962 and shortly after the building was demolished and site redeveloped.

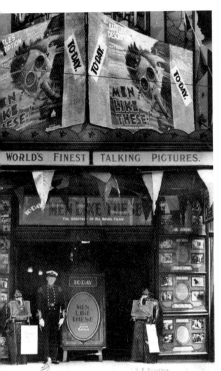
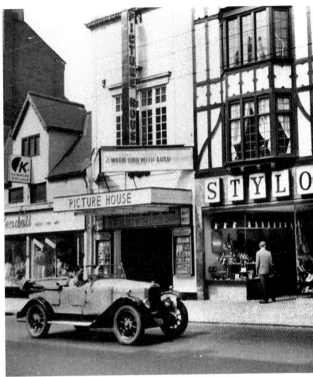

Picture House/ABC, High Street

Above left: Designed by architect E. H. Walker, the informal opening of the Picture House was on Monday 7 September 1914, the formal opening on 28 September. The owners sent out 1,000 invitations, with the announcement that the mayor, Councillor P. Stirling, would perform at the opening ceremony. The Picture House was taken over by Associated British Cinemas (ABC) from June 1929 and during the bank holiday of 5 August 1929 the cinema showed talkies for the first time with *The Singing Fool*, starring Al Jolson.

Above right: In June 1964 a spokesman at the Picture House said that alterations were planned for the cinema, and would include new toilets, heating, ventilation, seating and the modernisation of the projection room with new equipment. Twenty-three seats were to be removed, reducing the total number to 1,000. The Picture House would no longer go under that name, but was to be known as the ABC. The Picture House showed its last films on 28 October 1967 and opened as a bingo hall on 12 December 1967.

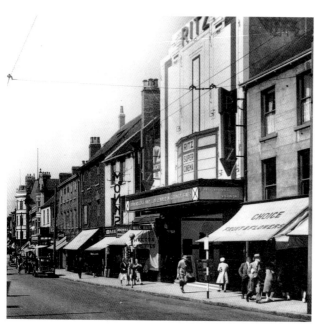

Ritz/Odeon, Hall Gate

The Ritz was formally opened on Monday 26 November 1934, seating around 2,500. The screen measured 24 feet by 18 feet and the film attractions in the opening week were *Murder at the Vanities* and *The Last Round Up*. At midnight on Saturday 2 April 1955, the Ritz passed into the ownership of the Odeon-Gaumont Group and was extensively modernised, including the installation of cinemascope. The cinema opened as the Odeon from Tuesday 24 May 1955 and screened *The Country Girl*. The premises closed on 7 July 1973, demolition occurring to the auditorium shortly afterwards, and in recent years the frontage has also suffered a similar fate.

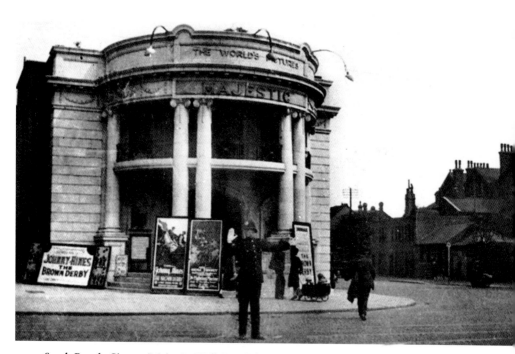

South Parade Cinema/Majestic, Hall Gate/Thorne Road junction

The South Parade Cinema opened on Thursday 9 December 1920, after overcoming many difficulties. The South Parade Cinema Company Ltd commenced construction work around March 1920. Dentist A. E. Reed was the scheme's original promoter. Building work was undertaken by Swift & Co. of Doncaster, at a cost of around £24,000. In time, a new company was formed by local builders Swift, Haslam & Hinchcliffe, although the company's name was retained.

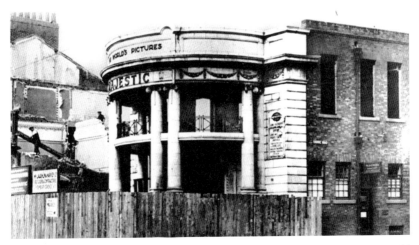

The cinema auditorium could accommodate 1,100, while a further 700 could be seated in the balcony. On 22 September 1922, the cinema announced it was operating under new management and was to be known as the Majestic. The Majestic changed hands in June 1927, and again in June 1928, being bought by Provincial Cinematograph Theatres (PCT). Talkies came to the Majestic on 30 September 1929, but it closed in 1933 to be superseded by the Gaumont.

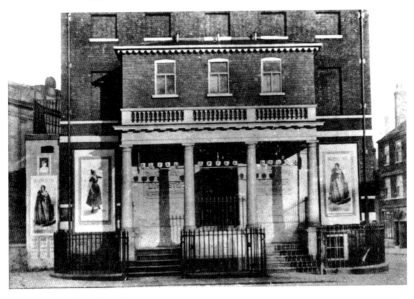

Theatre Royal, Market Place

The proposal to erect a theatre in the Market Place was brought before Doncaster Town Council on 4 October 1774. A design by William Lindley of York was accepted and the first stone was laid on 25 April 1775. On 7 August 1776, Tate Wilkinson, a well-known contemporary actor and entrepreneur, obtained the theatre lease at a yearly rental of £70, and under his management, which lasted until around 1804, the theatre enjoyed immense popularity and became a fashionable place to attend. Performances by touring companies took place during the annual race meetings and a wide-ranging programme was produced. Many noted actors and actresses appeared at the theatre. These included John Kemble, Edmond Kean and Mrs Siddons, who visited Doncaster in 1799.

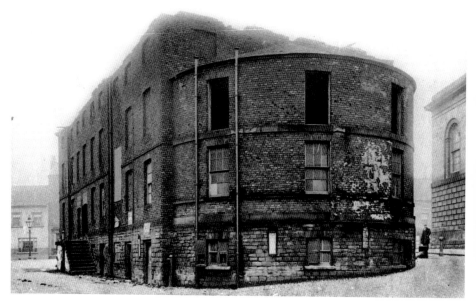

By 1806, the theatre was at its height and the resultant wear on the fabric of the building necessitated improvements and alterations on 7 December 1814, at an estimated cost of £782. Throughout the nineteenth century numerous managers took control of the theatre, and these included Robert Fitzgerald, Charles Cummins, Thomas Brooke and John W. Chapman.

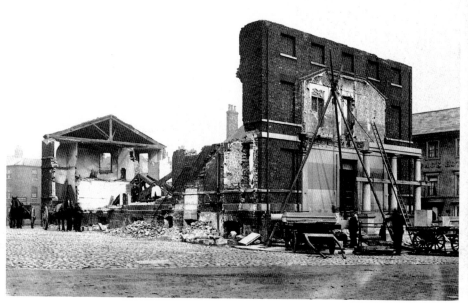

By March 1900, not much of the old Theatre Royal was left standing. The building was an eyesore. 'It is an ugly, dirty building on one of the best central sites of the town', it was claimed. And it was the source of very little profit for its owners, the Corporation. So, it was the general opinion that it was a good thing the old theatre was going to be replaced by the Grand Theatre, in Station Road. The site of the old theatre was to be used by the market.

Doncaster District

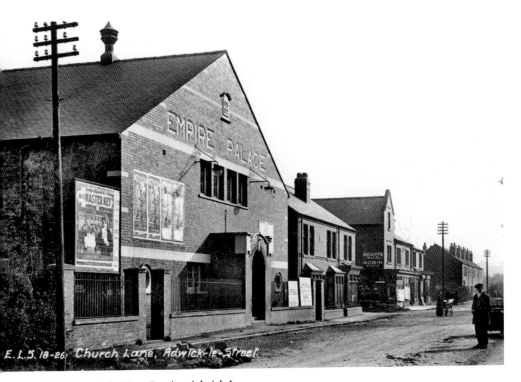

E.L.S. 18-26. Church Lane, Adwick-le-Street.

Adwick-le-Street, The New Empire, Adwick Lane
The Northern Counties Cinema Company opened the New Empire Cinema on Monday
2 December 1912. It seated around 800, featured a 24-foot-wide proscenium and talkies had
arrived there by 1940. The New Empire, latterly owned by Intimate Cinemas (Adwick) Ltd,
closed in May 1958. The building still survives, housing a clothing factory.

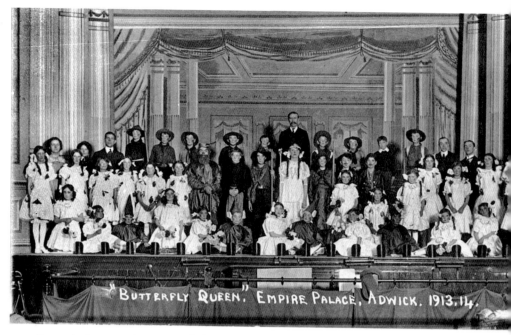

Scene during a performance of the *Butterfly Queen* at Adwick-le-Street's Empire Palace in 1913.

Armthorpe, Scala Cinema, Church Street

The Scala Cinema opened on Thursday 24 October 1929. It accommodated 1,000 people on the ground floor and 400 on the upper circle. The building was designed by Pontefract architects Garside & Pennington and sound was installed by November 1930, the first film being *On with the Show*. The Scala survived until November 1959.

Above and below: Askern, The Picture House, Moss Road

The *Don. Gaz.* of Friday 29 August 1919 said it was proudly reproducing by courtesy of architect T. H. Johnson, Doncaster, a drawing showing the projected Askern Picture House. Occupying a site in the centre of the village, the cinema opened a little later. It was constructed of brick, with the front finished in white Portland cement, and its architecture was a free treatment of the Classical Renaissance style. The *Gazette* added: 'Internally the Picture House will provide accommodation for from eight to nine hundred spectators, the seats both on the ground floor, and the gallery sloping towards the screen so as to secure a good view for all patrons.' The idea for the cinema was first projected some years earlier, 'but has been held up by the War,' concluded the *Gazette*. During October 1930 the cinema was equipped with a Morrisons' Sound Performance system. Two former managers of the establishment included J. Spivey and Lawrence Jones; closure came on 18 July 1964.

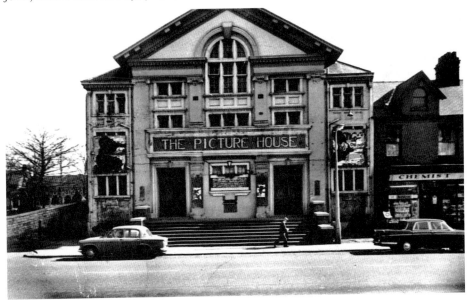

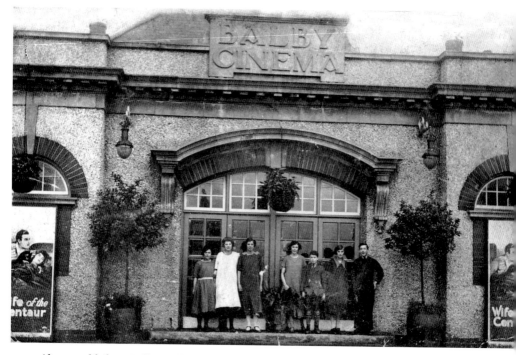

Above and below: Balby, Balby Cinema, High Road

Balby Cinema opened on 5 September 1921. Inside, a large, airy hall, 99 feet by 39 feet, was tastefully decorated in plaster and carpeted throughout with Wilton. All seats were on the ground level, and were of the tip-up upholstered variety, in green plush. The floor was exceptionally steep, with a rise of one in ten, thus ensuring everyone in the audience a clear view of the screen. Seating accommodation for 720 persons was provided.

A name that became synonymous with the Balby Cinema was that of manager Albert Dobney. For thirty-six years he lived in Balby, next door to the cinema! He ran children's Saturday matinees for thirty-four years. At one time, 400 attended in the morning and 600 in the afternoon. After the matinees, Albert Dobney was a familiar figure with his red flag as he saw the children across the road. 'I always like to see them safe,' he once said. Balby Cinema closed on 11 June 1960.

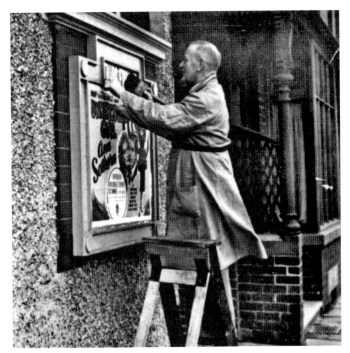

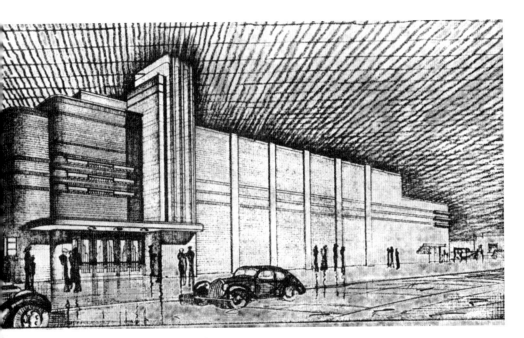

Balby, The Windsor, Warmsworth Road

The Windsor cinema at the Oswin Avenue/Balby Road junction was opened by Suburban Cinemas (North Midlands) Ltd of Worksop on Monday 1 August 1938. The proscenium was 34 feet wide and the opening films were from Monday to Wednesday *Second Best Bed*, and from Thursday to Saturday *The Prisoner of Zenda*. Seating was provided for approximately 900 in the auditorium and 300 in the circle.

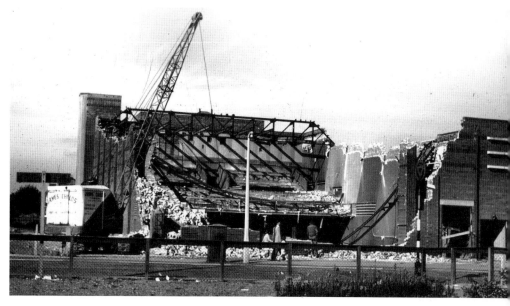

The Windsor Cinema was taken over by the Star Cinema Group on 1 March 1954 and improvements were carried out, including the installation of cinemascope. Roulette and bingo were to replace films, and the cinema was to be renamed the Windsor Casino, it was revealed at the beginning of November 1962. The cinema finally closed on 27 June 1964 and was demolished shortly afterwards, as seen in the picture taken by Geoff Warnes on 29 August 1964.

Bawtry, The Palace, South Parade

Local saddler Tom Frost financed the building of the Palace Cinema shortly before the First World War. But it was not until the 1920s that there was any continuity at the venue. In the preceding years the building was used by the Army as a billet, and at one time it was used to cultivate mushrooms!

For some time, Ken Simkins held a lease on the Palace, and during the early 1950s a Mr Eckard of Three Star Cinemas took control. The cinema closed around 1961.

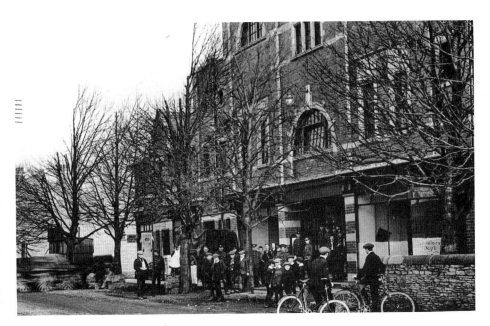

Bentley, Bentley Coliseum, High Street

Opening on Monday 7 September 1914, the Bentley Coliseum had provision for staging variety and dramatic productions (with eight dressing rooms), as well as the latest offerings from the motion picture world. The Coliseum had a frontage of 120 feet, a large proportion of which was occupied by four shops, three of which were to the left and one to the right of the hall itself. Above the three shops, on the left, were two spacious billiard rooms. The proscenium opening measured 30 feet wide and 125 feet high.

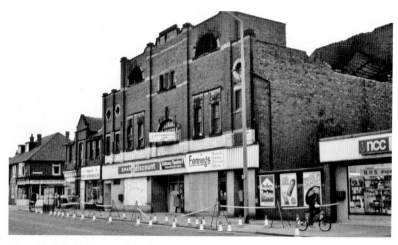

The Bentley auditorium was on the two-tier principle and had comfortable seating accommodation for about 1,400 people. On the ground floor, which was on the same level as the foyer, were the orchestra stalls and pit. Heading the opening night performance at the Coliseum was James Bell's troupe of young stars. In later years the premises were used as a gymnasium, and were gutted by fire in September 1981.

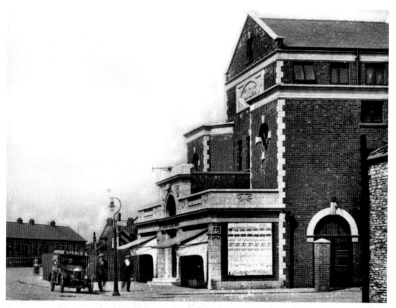

Carcroft, The Picture House, High Street/Park Avenue junction

Carcroft's Picture House opened on Friday 1 August 1924, and was situated almost opposite the Bullcroft Colliery gates. The architect was Blythe Richardson of Doncaster and the contractors Ward & Crossley of Carcroft. The building was of brick, with terracotta dressings. Seating accommodation was for 200 people in the balcony and 645 in the main hall. There were plain rows of wooden seats in the cheap parts, the next best were upholstered in red leather, while the front seats and those on the balcony, for which 6d extra was paid, were tip-up style and upholstered in red plush.

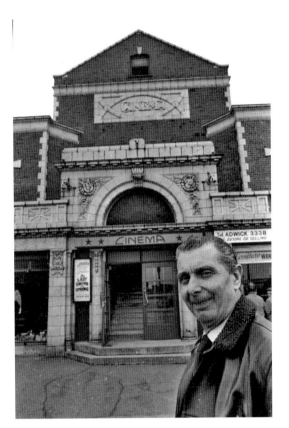

Right and below: In August 1977, the cinema's controller, Brian Megson (pictured), warned that the new rate assessment he had received could force him to close down the building. He had spent two years and £12,000 converting the premises from a bingo hall back to a cinema. The cinema has since been demolished.

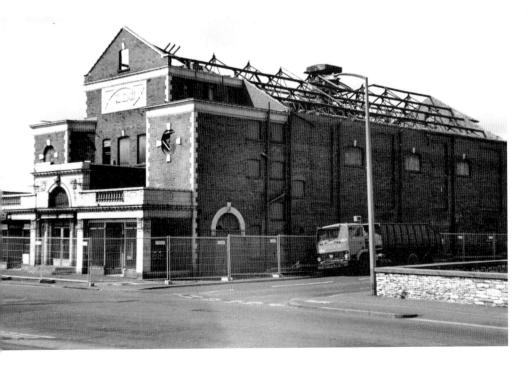

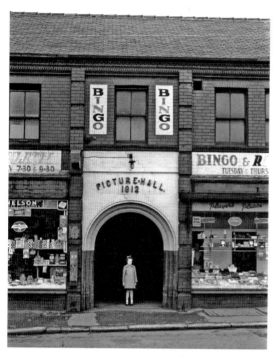

Conisbrough, Globe/Picture House, Church Street

The cinema at Conisbrough opened in 1912, becoming known as the Globe or Picture House. There was an arched front entrance, flanked on both sides by shops. Musical backing for the silent films was provided by a small orchestra, audiences sometimes numbering around 650. Later, a solitary pianist provided the accompaniment. Some of the cinema's equipment was upgraded during the early 1950s, but by the end of the decade operations had ceased. For a time bingo sessions were held there, although this was short lived, the site being required for redevelopment in the area.

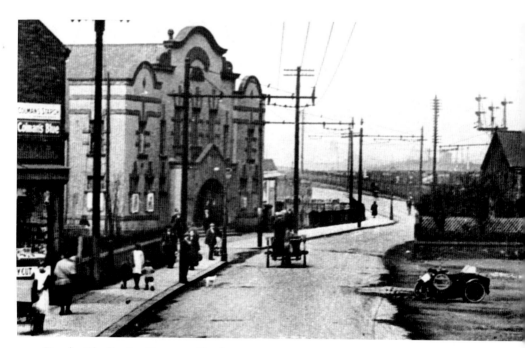

Denaby, The Empire, Doncaster Road

Built of brick and pebble dash, the Empire opened on 3 November 1913, with seating for 1,200. The first films shown were *Alone in the Jungle*, *The Imposters* and *Ivanhoe*. The talkies came to the Empire in January 1931.

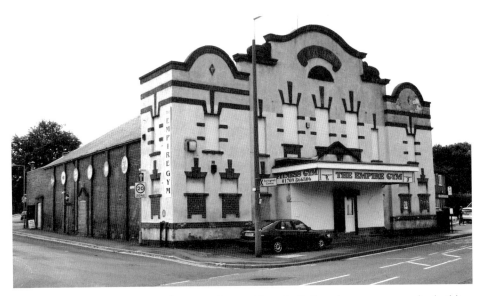

The Empire closed in 1962 and reopened as a bingo hall. In subsequent years the building housed a snooker hall, and later a gymnasium and fitness club. The photograph was taken on 28 July 2011.

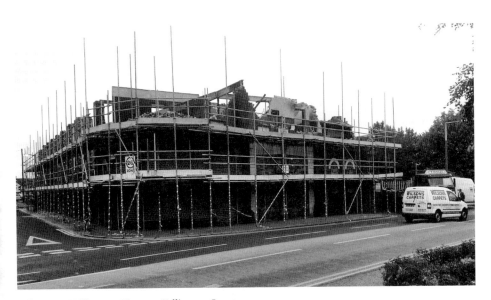

Edlington, Edlington Cinema, Edlington Lane

The Edlington Cinema Ltd opened the Edlington Cinema on Saturday 18 June 1921. It was designed by J. Simmons & Son and could accommodate around 900 people. Built of brick and stone, the building's main contractor was T. H. Wilburn Ltd. The *Don. Chron.* of Thursday 26 February 1959 said that *The Bridge on the River Kwai* would be the 'grand finale' for the thirty-seven-year-old cinema at Edlington 'when it closes down on Saturday week ... Dwindling audiences have meant the same fate for the village's only cinema as many other cinemas up and down the country ... the cinema cost more than £10,000 to build ... Mr John Draby (54) has been the manager at the cinema for 28 years,' said the newspaper. The photograph shows the cinema partly demolished in June 2008.

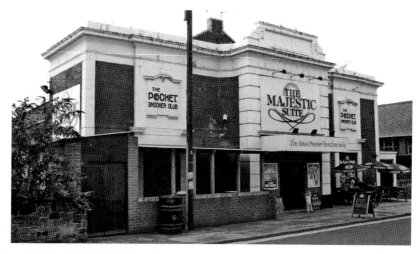

Mexborough, Majestic, Bank Street

Opening on Monday 7 January 1929, the Majestic Cinema was built by T. J. Jenkinson & Sons Ltd to the designs of Harry Slater. The auditorium seated 1,000 and the first film, played from Monday to Wednesday, was *The Women On Trial* while *Two Arabian Knights* played from Thursday to Saturday. A Western Electric Sound System was installed in September 1930 and *Paris* was the first film screened. In the mid-1950s the Majestic became part of the Star Cinema Circuit and CinemaScope was subsequently installed, opening with the film *The Long Grey Line*. Bingo was only tried for a short period in the early 1960s and Star Cinemas closed the Majestic on 2 January 1972. A little later the Majestic was acquired by Axholme Cinema Services and on 8 November 1972 it reopened with *Lawrence of Arabia*. This continued for another eleven years, finally closing on 29 June 1983 with *The Missionary*. The building is still extant as a snooker club and function suite.

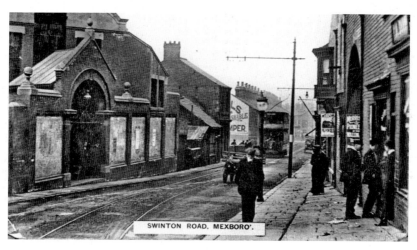

SWINTON ROAD, MEXBORO'.

Mexborough, Olympia/The Empire, Swinton Road

The Palace (Mexborough) Ltd took over the Olympia, which was being used as a sporting venue, and reopened it as the Empire Palace on 19 June 1911, supporting variety and cinema entertainment. Sound was installed in September 1929 and CinemaScope in January 1955, opening with *The Robe*. Star Cinemas took control in 1955 and carried out a complete modernisation.

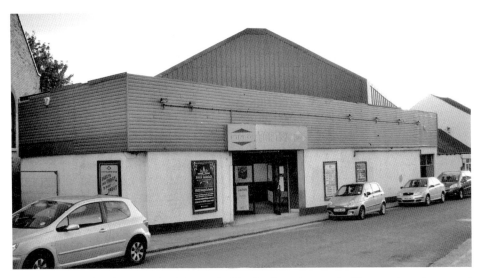

Bingo was introduced on certain nights at the Empire from June 1961. The premises also opened as a nightclub called the Playmate Club from June to July 1962 and showed the last film, *The Immortal Monster*, on 26 July 1962. Full-time bingo then took over and has operated under various companies, including Star, EMI, Coral and Gala. The photograph was taken on 28 July 2011.

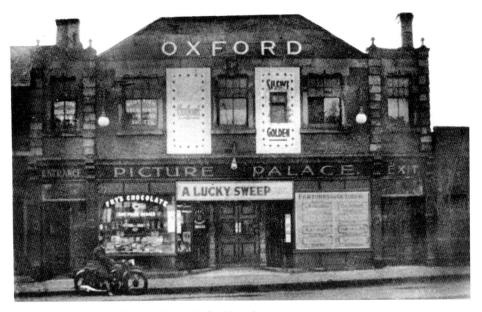

Mexborough, Oxford Picture Palace, Oxford Road

The Oxford was opened to the public on Monday 21 October 1912. It was the enterprise of Councillor F. Woofinden, and the cinema could accommodate 700 people in three divisions of raised floor. The hall was 65 feet by 40 feet, and there was a raised stage 10 feet deep with a proscenium 25 feet wide. The builders were Messrs Adcock of Barnsley, and the architect was a Mr Turner of Barnsley. A lease on the hall was taken by Messrs W. H. Melton and J. J. Woofinden. The programme for the opening night was *The Colonel's Ward*, a fine Indian drama in two parts. The Oxford closed in June 1948 and was demolished during the 1970s for a relief road.

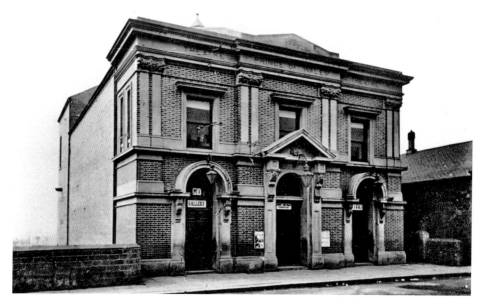

Above and below: **Mexborough, Prince of Wales Theatre/Hippodrome, High Street**
The Prince of Wales Theatre was opened by a Mrs Thomas Carter Livesey on 18 December 1893, the first show being a play, *Grelley's Money*. The frontage was in the Italian style, the stage was 50 feet by 20 feet and the auditorium seated 1,000. The first films were shown at the Prince of Wales on Christmas Day 1896. Animated pictures were seen from June 1908. Two years later the theatre was sold to the Smith family from Dewsbury, and on 19 October 1912 the *South Yorkshire Times* said that the theatre would in future be called the Mexborough Hippodrome. Alterations and additions were made to the building in the following years and this included new seating and electricity being installed, as well as the building of an area on the roof to house Bioscope cinematograph apparatus. The 1930s saw the Hippodrome open and close with various schemes and under different organisations until final closure came in 1937. Two years later, the building was partly demolished; the remainder was pulled down in the post-war years.

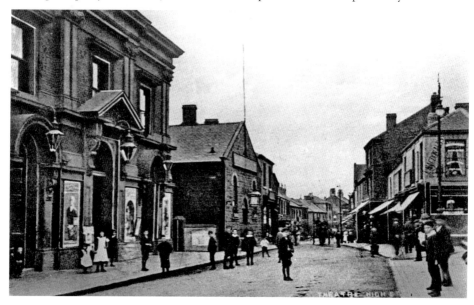

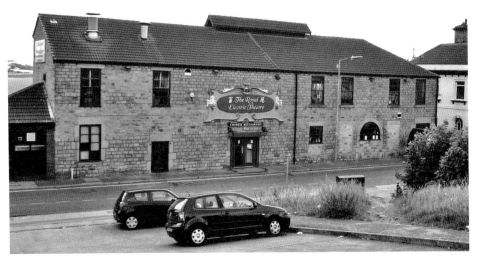

Mexborough, Royal Electric Theatre, Bank Street
Built by G. H. Smith & Son to the designs of George White & Sons, the Royal Electric
Theatre opened on 28 May 1911, seating about 850. In 1912 it was taken over by Photoplays,
redecorated in 1913 and 1928 and renamed The New Royal Electric Theatre in 1940. But it was
known as the Royal Cinema by the beginning of the following decade. A CinemaScope screen was
installed in January 1955, and the first film shown was *Knights of the Round Table*. P. H. Blake
Ltd took over in 1958 and bingo sessions were introduced on certain nights from August 1961.
The premises closed on 2 June 1962 with *Morgan the Pirate* and *Atlantis, the Lost Continent*.
Opening as the Royal Casino, the building was occupied until the early 1980s, when it was left
derelict for a number of years. In 1990 it was transformed into a restaurant. The photograph was
taken on 28 July 2011.

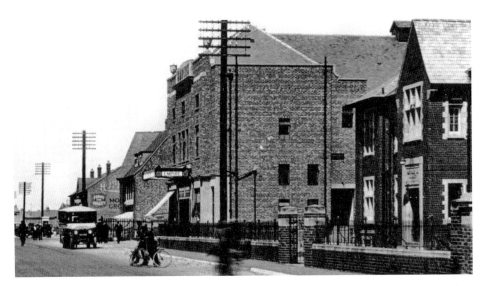

Moorends, The Empire, Marshlands Road
Built by W. A. Kellett, the Empire opened on 24 May 1931 with a proscenium 30 feet wide. Sound
was installed by 1940, but fire caused severe damage to the building on 28 February 1952. The
Empire never showed films again, though it did exist as bingo hall for a time.

59

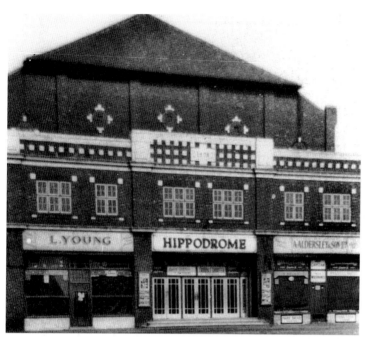

Rossington, The Hippodrome, Queen Mary's Road
The Hippodrome opened on 5 July 1929, the construction work costing about £15,000. It seated 1,100 and opened with *The Secluded Roadhouse*. Latterly, the Hippodrome was run by S & E Cinemas; it closed in June 1962 and was demolished a little later. Photograph reproduced courtesy of Charlie Worsdale.

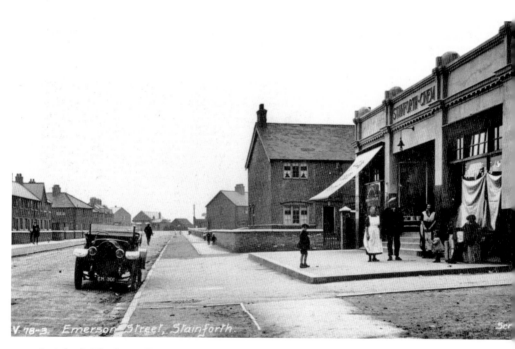

Stainforth, The Savoy, Emerson Avenue
The Savoy, opening in 1922, was built by Frederick Hopkinson & Co. Ltd to the designs of L. Hopkinson of London and Worksop. Among the cinema's former managers were Jack Lister and Ernest Wright. Seating more than 800, the Savoy became the property of Star Cinemas (London) in 1956, surviving until the late 1950s. In subsequent years the building was used as a snooker centre.

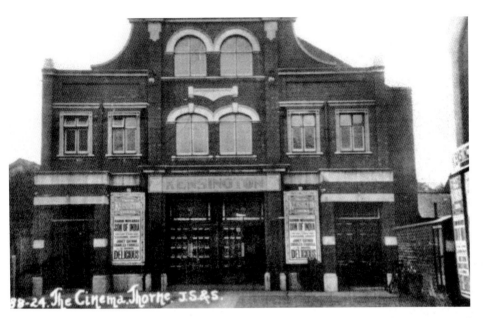

Thorne, The Kensington, Fieldside

Designed by Frank Turner, the Kensington opened on Monday 4 April 1927. The building had seating for around 1,000, the balcony accommodating 200. The proscenium was 20 feet wide. Star Associated Holdings renamed the cinema the Ritz in 1967, and it opened with *My Fair Lady* but closed in September of that year. Later, the building became a Star Bingo Club and eventually a nightclub named Merlin's.

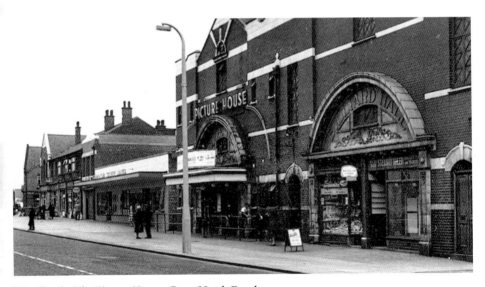

Woodlands, The Picture House, Great North Road

The Picture House opened to the public on 3 January 1923 with *The Three Musketeers*. Owned by W. Nuttall, the building had seating for 850, including the ground floor and balcony. A BTH sound system was installed in 1929 and CinemaScope in 1956. The building alternated between films and bingo between May 1962 and 31 June 1967, when the final film shown was *The Ten Commandments*. Bingo continued thereafter.

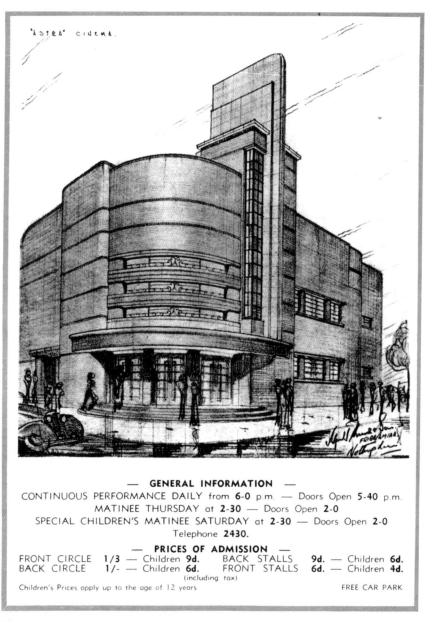

'ASTRA' CINEMA.

— **GENERAL INFORMATION** —
CONTINUOUS PERFORMANCE DAILY from **6-0** p.m. — Doors Open **5-40** p.m.
MATINEE THURSDAY at **2-30** — Doors Open **2-0**
SPECIAL CHILDREN'S MATINEE SATURDAY at **2-30** — Doors Open **2-0**
Telephone **2430**.

— **PRICES OF ADMISSION** —

FRONT CIRCLE	**1/3** — Children **9d.**	BACK STALLS	**9d.** — Children **6d.**	
BACK CIRCLE	**1/-** — Children **6d.**	FRONT STALLS	**6d.** — Children **4d.**	

(including tax)

Children's Prices apply up to the age of 12 years FREE CAR PARK

Wheatley, The Astra, Beckett Road

When he opened the Astra Cinema on Monday 30 January 1939, mayor of Doncaster Councillor E. Scargall thanked the cinema directors for their generosity in devoting the proceeds of that afternoon's entertainment to the Doncaster Royal Infirmary. Afterwards, the Mayor and Mayoress saw the programme, the main feature of which was *In Old Chicago*. The cinema showed its last film on Saturday 20 June 1964. Young patrons of the Astra were looking forward to a fancy dress competition at the matinee on that day, but it was not held. The Astra had reopened as a cinema three months earlier, after a spell as a bingo hall. The Astra's last film was the Dirk Bogarde comedy *Doctor in Distress*. Manager Peter Bray led his staff on to the stage to say goodbye to the patrons during the interval on the final Saturday night.

Rotherham

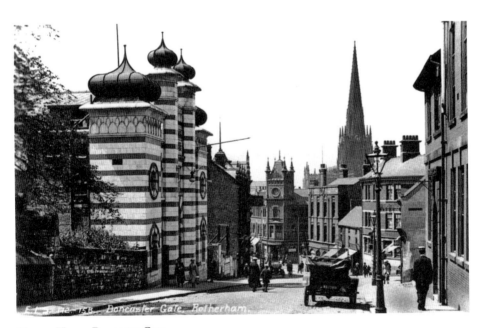

Cinema House, Doncaster Gate

Rotherham (Cinema House) Ltd opened the Cinema House in Doncaster Gate on 9 March 1914. It was designed by W. G. Beck of Sheffield in the Moorish Revival style, complete with four Russian-style onion-shaped domes, two octagonal and two square ones. The contractor for the faience frontage was Hathern Station Brick & Terracotta Co. Ltd of Loughborough. Seating 900 in the stalls and small balcony, the cinema was taken over by Cinema (Rotherham) & Electra Ltd in 1931 and sound was installed by the end of August of the same year.

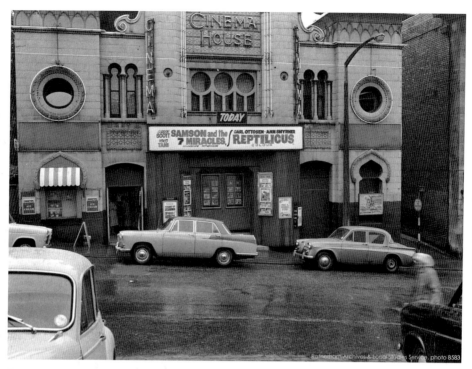

Above and below: When Star Cinemas (London) Ltd took control of the cinema in 1939, a number of modernisation and extension schemes took place before closure as a cinema came on 1 June 1963, the last films being Norman Wisdom's *Just My Luck* and Jeff Chandler's *War Arrow*. Disappointingly, when the building reopened as a bingo club, its exterior features were subsequently lost in a modernisation scheme. Cinema House Bingo, and later Coral Bingo and Social Club, have occupied the former Cinema House, but it was seriously damaged by fire in 2004 and demolished in 2009. The top photograph is reproduced by courtesy of Rotherham Archives and Local Studies Service (No. 08583); the bottom one was taken by Richard Roper on 20 March 2006.

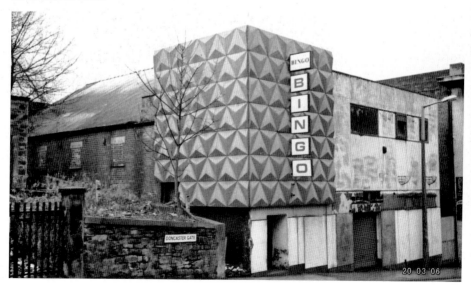

Right and below: Civic Theatre, Catherine Street

Rotherham Civic Theatre opened on 7 March 1960, in a converted Congregational chapel dating from 1867. The conversion cost about £30,000 and it is a medium-scale proscenium arch theatre playing host to a wide programme of professional and amateur dance, drama, musicals, children's theatre, comedy, music and pantomime. On Rotherham The Unofficial Website, it is stated: 'Little is known of the history of theatre in Rotherham before the late 19th Century. There appears to have been no permanent stage but doubtless touring companies performed in inn yards and halls. Public performances were subject to licensing by the town authorities and probably quite difficult to get in Rotherham. The town was very Protestant, not to say Puritan, in outlook and actors and travelling companies were generally regarded as deeply sinful and depraved. Before the first cinema opened, animated features were shown in the Town Hall Assembly Rooms, previously the Mechanics Institute from 1902 to 1911, and also Clifton Hall.' The top photograph was taken on 4 March 1960; the one below in March 1962. Both pictures are reproduced courtesy of Sheffield Newspapers.

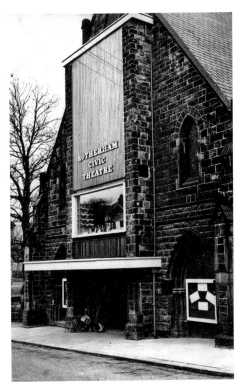

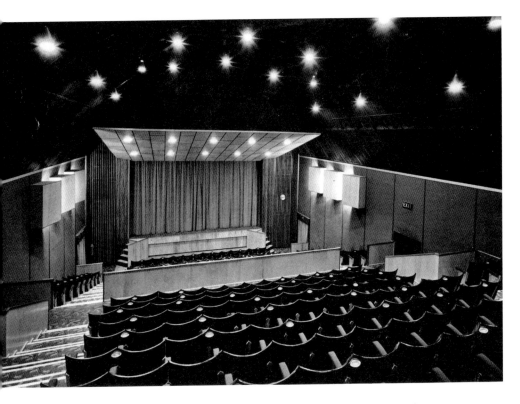

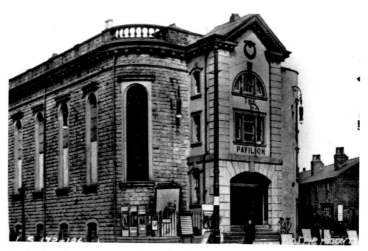

Electric Pavilion/Electra

The Electric Pavilion in Effingham Street was housed in a large, three-storey stone building which was a former Zion chapel (United Methodist church) dating from 1860. It opened as the Electric Pavilion cinema, seating about 600, on Saturday 15 July 1911 at 2.00 p.m. Initially leased to Rotherham Theatre Ltd, it passed to the Electric Theatre Company Ltd in 1916, and in the 1920s the proprietor was Cinema (Rotherham) and Electra Ltd. During this period the name was changed to Electra Picture Palace, but it is not clear when a sound system was installed. The final film before closure on 26 April 1930 was *Free Lips* and the building was eventually demolished.

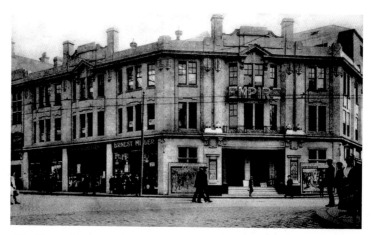

Empire/Essoldo/Classic/Cannon, High Street/West Gate corner

Designed by Chadwick & Watson of Leeds, the Empire Theatre, incorporating a distinctive white faience frontage, opened on Monday 15 December 1913. The theatre was owned by two publicans, William Hafferty and Joseph Steeples, and could seat around 1,500. Incorporated from the outset was a projection room, and short films were shown regularly before the full time conversion to silent cinema, the building opening on Monday 2 May 1921 as the Empire Picture House. Later in the decade, under the lessees Rotherham District Cinemas Ltd, it became known as the Empire Super Kinema and sound was installed by 23 November 1929. In the following years, the lease was held by ABC and Rotherham District Cinemas Ltd. The photograph is reproduced by courtesy of Rotherham Archives and Local Studies Service (No. 15869).

Right and below: In 1951 the cinema became part of the Essoldo Circuit (Control) Ltd, and two years later CinemaScope opened at the Empire. The cinema, named Essoldo in 1955, suffered extensive fire damage in January 1958 and was sold to the Classic Cinemas Group, being named Classic in 1972. Twinning of cinema occurred in 1978 and ten years later the cinema was sold to the Los Angeles-based Cannon Cinemas Ltd. However, on 22 February 1990 the cinema closed; the last films were *Shirley Valentine* and *Sea of Love*. The building survives and is part split as a nightclub and a snooker club. The top photograph was taken on 9 January 1978 and is reproduced courtesy of Sheffield Newspapers; the one below dates from 31 July 2011.

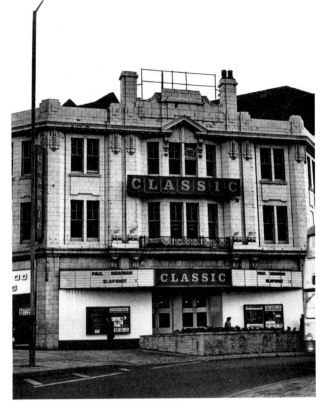

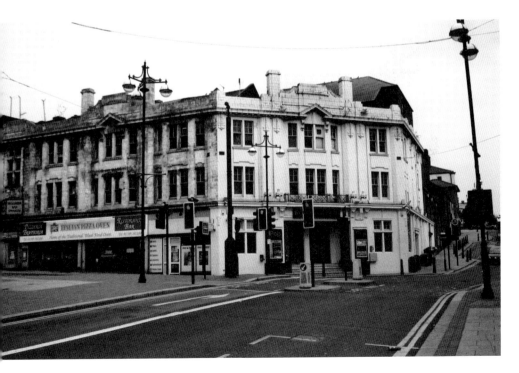

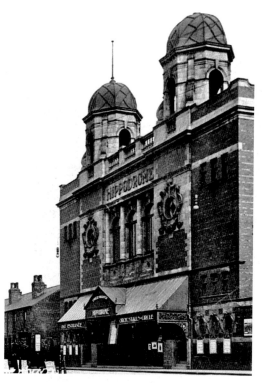

Left and below: Hippodrome, Henry Street
Built in brick and stone by J. Parkinson & Sons
of Blackpool to the designs of Chadwick &
Watson of Leeds, the Rotherham Hippodrome
Theatre had an Italian Renaissance façade
flanked by two octagonal towers topped by
large domes. It opened on 3 August 1908
as a variety theatre, with Thomas Edward
Fox as lessee and seating for 2,500, and
animated pictures were part of the programme.
Among the music hall stars to appear there
were George Formby and Gracie Fields. On
Saturday 2 July 1932 it closed as a theatre and
reopened 17 October 1932 as a cinema, with
Maurice Chevalier in *Playboy of Paris* and
Clara Bow in *No Limit*. The seating capacity
was reduced to 1,800, and the cinema operated
under the Rotherham Hippodrome Ltd.

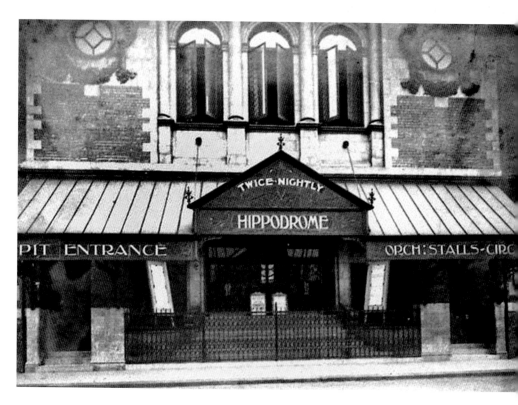

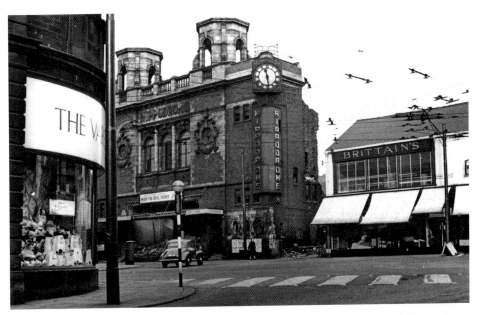

Above and below: The Hippodrome was listed as having 1,200 seats in 1950, and CinemaScope was installed in 1955. Four years later, Rotherham Council acquired the Hippodrome, needing the site for inclusion in a new civic centre. Closure came on 19 December 1959, with a double-bill 'X' certificate programme: *When The Devil Drives* and *Runaway Daughters*. In the following year, it was demolished. Both photographs are reproduced by courtesy of Rotherham Archives and Local Studies Service (Nos 14739 and 02698).

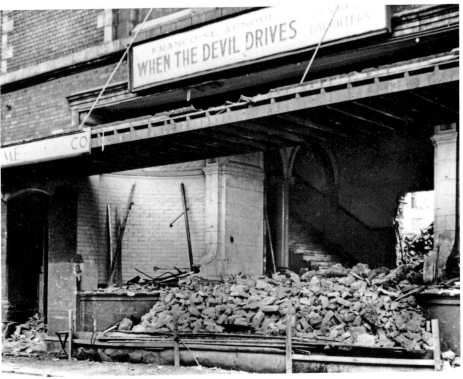

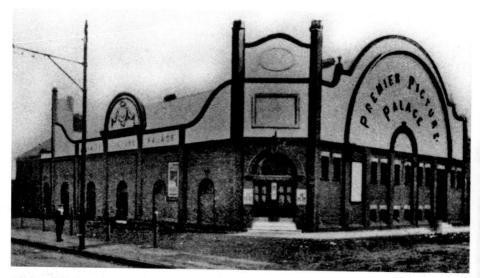

Above and below: **Premier Picture Palace, corner of Kimberworth Road and Fernham Park Avenue**
The Premier Picture Palace opened on 9 December 1912. It was built to the designs of H. H. Alien of Manchester by the Leeds firm of William Airy & Sons and included 1,100 tip-up seats on a single raked floor. Initially, the cinema was leased by G. E. & G. W. Smith of the Rotherham Hippodrome. The auditorium measured 84 feet by 67 feet, with a proscenium width of 30 feet. The first talkie film shown, using the BTH system, was Eddie Cantor in *Whoopee* on 8 July 1931. By 1956, the Premier Cinema, as it became known, was taken over by Star Cinemas and underwent considerable alterations, including the installation of CinemaScope, but seating capacity was reduced to around 700. During 1960, films were fighting a losing battle with bingo, and this continued up to 30 October 1961, when they were only shown on a Saturday afternoon for the Star Junior Club, but this was abandoned on 4 September 1962. Bingo continued for another two years when the cinema became the Premier Casino; then it was converted into a snooker club, and it operates today as a Riley's snooker hall. The top photograph is reproduced by courtesy of Rotherham Archives and Local Studies Service (No. 05451); the bottom one was taken by Richard Roper on 18 March 2004.

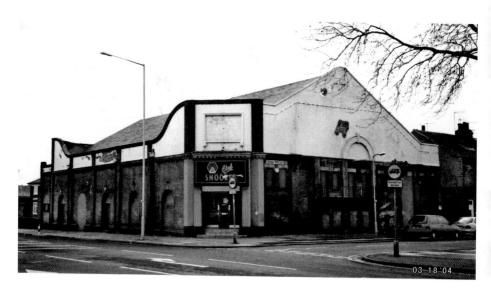

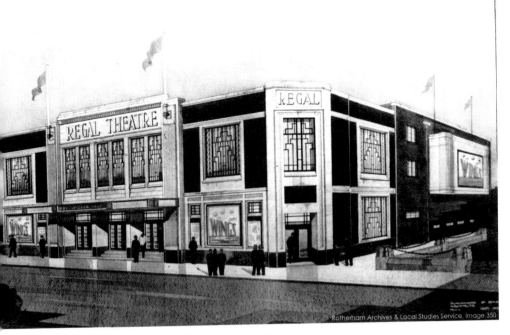

Above and below: **Regal/Odeon/Scala, Corporation Street**

The Regal Cinema opened on 22 December 1934, with Sidney Howard in *Girls Please*. Seating 1,825 (1,097 stalls, 728 circle) without any pillars or obstructions, it was designed by Blackmore & Sykes of Hull and built by the owners, Thomas Wade & Sons Ltd, Wath-upon-Dearne, who then leased it to Lou Morris Theatres of London.

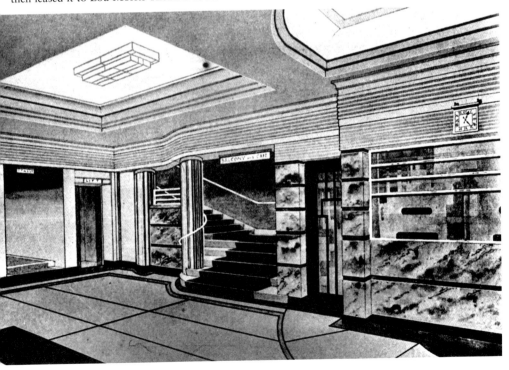

71

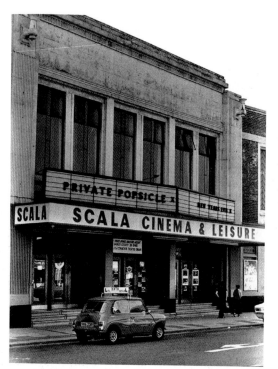
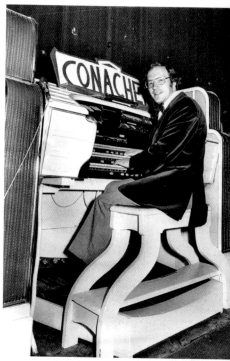

Above, left and right: During the 1940s the Regal Cinema was leased to the Odeon circuit, and in 1946 it was renamed Odeon. CinemaScope was installed in 1954, and in 1975 it was sold to an independent operator (which included Twainville Ltd of Derby and DOF Leisure Ltd), who changed the name to Scala Cinema. The photograph on the left was taken on 4 July 1982; the one on the right shows David Lowe with the Conacher theatre organ on 20 October 1979.

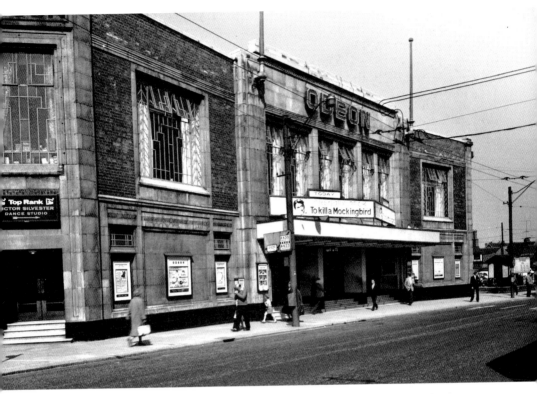

Above and below: For a short period Twainville leased the cinema to Axholme Cinema Services, but it had returned to Twainville by July 1983, only to close on 23 September 1983 with the film *Porky's*. In time the building became a bingo hall, initially named Ritz but now Mecca. The top picture is reproduced by courtesy of Rotherham Archives and Local Studies Service (No. 09172). The bottom one was taken by Richard Roper on 18 March 2004.

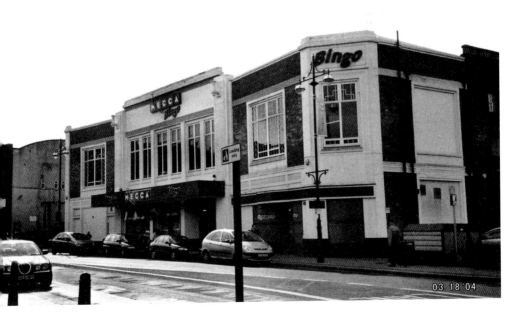

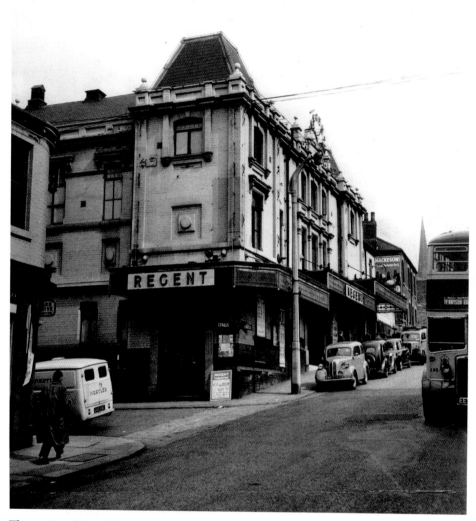

Theatre Royal/Royal Picture House/Regent

The Theatre Royal opened at the Howard Street/Nottingham Street junction on 1 January 1894 with a drama title, *Manhood*. The building was designed by Joseph Platts, built by William Thornton & Son, seated 2,000 and replaced a former theatre of the same name. The new theatre featured two square towers and a central entrance and was leased to the North of England Theatre Corporation Ltd. Following a short closure between 7 July 1915 and 6 September 1915, it reopened as a cine-variety theatre and was renamed the Royal Picture House. By 15 December 1930 a new projection room was added and Western Electric 'talkie' apparatus installed; the building reopened as the Regent Theatre with *The Grand Parade*. The seating capacity was 1,250 and the owners were Cinema (Rotherham) & Electra Ltd. The photograph was taken on 28 June 1957 and is reproduced courtesy of Sheffield Newspapers.

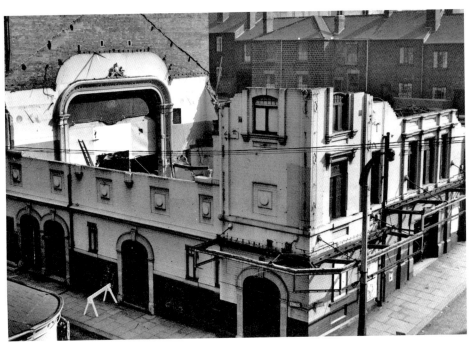

In 1935 the Regent reverted back to live shows, becoming known as the Regent Palace Of Varieties. Later the owner was Regent Theatre (Rotherham) Ltd and seating was for 1,000. Live entertainment continued until 15 June 1957, when the last show was 'Goodbye to Striptease'. In October 1957, the building was demolished and the town market hall now stands on the old site. Both pictures are reproduced by courtesy of Rotherham Archives and Local Studies Service (Nos 02872 and 02873).

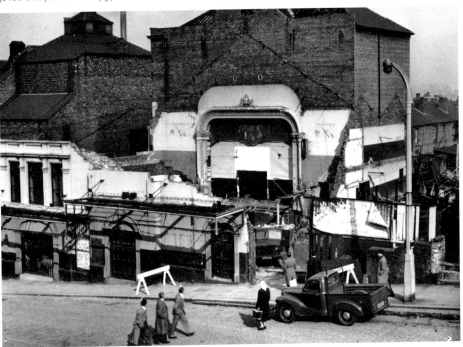

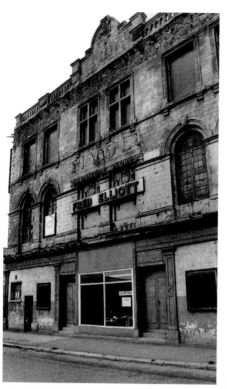

Left and below: Tivoli Picture House, Masborough Street

The Tivoli Picture House opened on 5 April 1913 in a three-storey building, formerly occupied by Henry Bray & Co. Ltd. The interior was remodelled by builder Robert Snell under the direction of architect J. E. Knight. C. H. Lord of Bradford was the owner, trading as Tivoli Pictures Ltd, and the premises seated 630-500 in the stalls and 130 in the balcony. In 1931, the cinema was re-designed by Scarborough-based architect Frank A. Tugwell. The seating was increased to around 1,100, and the first talkie shown was *The Gay Nineties*. A year later, the cinema was taken over by the Westminster Picture Palace Company. On 1 December 1955, *Purple Mask* was the first CinemaScope film seen at the cinema. Closure came on 31 January 1959; the final films were *The Proud Rebel* and *Handle With Care*. The building housed a furnishing warehouse and showroom named the Tivoli Furnishing Stores until the early 1970s. In 1988 it was purchased by Rotherham United chairman Ken Booth, and was demolished in July 1989. The top picture is reproduced courtesy of Sheffield Newspapers, the bottom one by courtesy of Rotherham Archives and Local Studies Service (No. 09276).

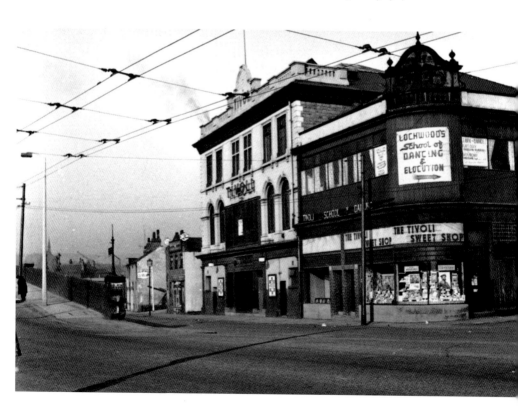

Rotherham District

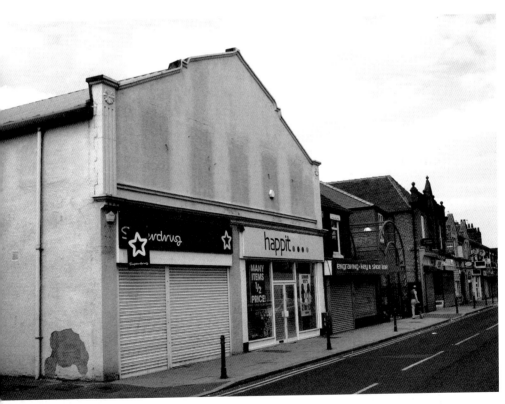

Dinnington Palace, Laughton Road, photograph taken on 31 July 2011.

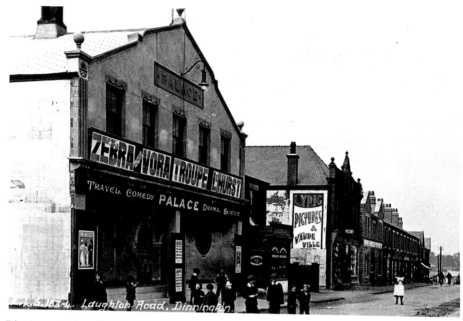

Dinnington Palace, Laughton Road

Dinnington Palace was built around 1915 by James England and several local businessmen. Allan Harvey, in *Palace Cinema* (1980), recalls that the establishment of the cinema was a great step forward for the area and a real money spinner. For the first year of the Palace there was a break in the film's programme for a 'live' stage show. The building was eventually converted for retail use. Off-centre to the right is the Lyric Theatre, built in 1910; James England was the main instigator of the building work. Allan Harvey notes that the actors who came to the Lyric and Palace usually lodged in New Street, then a very respectable area. He also adds: 'The Lyric had prosperous and lean years.' At one time it was a Salvation Army citadel, though during the Second World War it underwent a revival and was a popular venue for dancing. The Lyric was bought by the parish council in 1962 for £1,800.

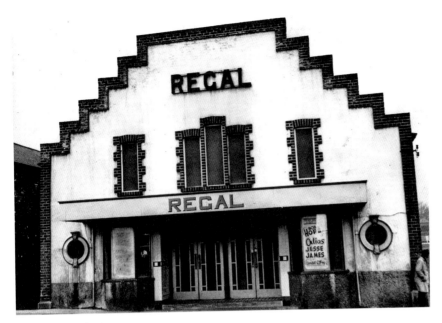

Kiveton Park, Regal Cinema

On www.kivetonwaleshistory.co.uk, it is stated: 'Anybody who grew up in Kiveton Park would have been very familiar with The Regal cinema, standing as it did on the site of what is now The Forge pub. For many decades, every Saturday morning, the Regal would be packed out with children looking forward to that week's showing. Lots of the people we've spoken to had very special memories of the Regal. Several of our older witnesses can even remember silent films being played there with a piano player at the front of the cinema offering an accompaniment!' CinemaScope was installed at the Regal in 1958, and closure came in April 1960. The photograph was taken in April 1960 and is reproduced courtesy of Sheffield Newspapers.

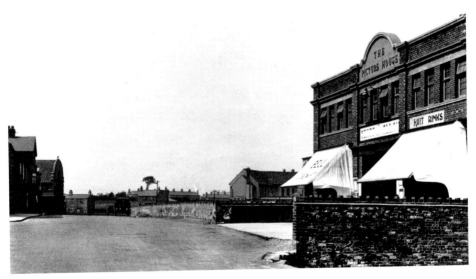

Maltby Picture House, Muglet Lane

This photograph of the Picture House in Muglet Lane, Maltby, was taken by Edgar Leonard Scrivens.

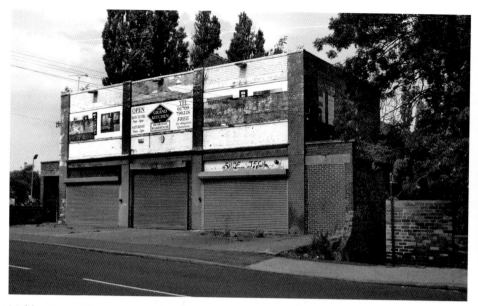

Maltby Picture House was run by the Leeds-based Star Cinema Company and ended its life as a bingo hall. The building is still standing, though the frontage is much altered, as seen in this photograph taken on 31 July 2011.

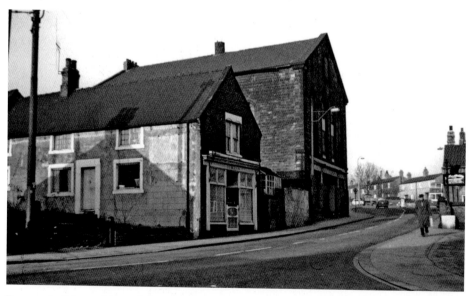

Rawmarsh, Princess Picture Palace, High Street

The Princess Picture Palace, opening on 4 March 1912 in the converted Rawmarsh Weslyan Chapel, seated 600 and was run by the Princess Picture Palace (Rawmarsh & Barnsley) Ltd. In 1917 the cinema was taken over by a Thomas Robinson, and sound was installed in 1930, with CinemaScope wide screen in 1955 after Mr Thomas Robinson Jnr took over from his father. The Princess Cinema closed on 1 December 1962 and was demolished in 1966 for the widening of High Street. The photograph is reproduced by courtesy of Rotherham Archives and Local Studies Service (No. 08975).

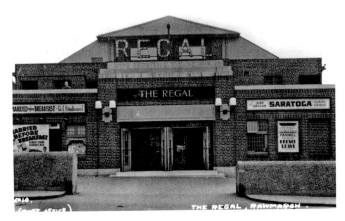

Rawmarsh, Regal Cinema, High Street

Opening on 5 October 1931, the Regal Cinema was built to the designs of Harold J. Shepherd by Heeley & Amalgamated Cinemas Ltd. It seated 1,054 patrons and featured a stadium-style auditorium with a more steeply raked balcony at the rear. The opening film was *Just Imagine*, shown from Monday to Wednesday, with *The Sea Beneath* screened from Thursday to Saturday during the inaugural week. The Regal Cinema was taken over by Star Cinemas in January 1955, and CinemaScope was installed by 28 February. The Regal closed as a cinema on 9 March 1963; it opened a little later as The Regal Casino with Star Bingo, but reopened as a cinema part-time from 29 March 1964. The final film, *Finders Keepers*, was shown on 5 April 1967. From that time it became a full-time bingo hall, then a snooker hall, and a supermarket. The photograph is reproduced by courtesy of Rotherham Archives and Local Studies Service (No. 11144).

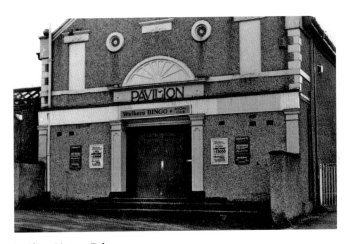

Swallownest Pavilion Picture Palace

The Pavilion Picture Palace at Swallownest opened on 24 December 1913. On www.j31.co.uk, it is mentioned: 'The Pavilion Cinema, now the snooker hall ... was managed by Alan Lax, seat prices ranging from about two new pence for the front seats (wooden, called the "chicken run") to about ten new pence for the stadium type 'balcony' where the seating arrangement guaranteed that you could see the screen rather than the back of someone's head. There were three changes of programme per week (four when Sunday opening started) plus a children's matinee on Saturday morning (known as 'The Tuppenny Rush'). The Pavilion Cinema closed in the late 1950s or early 1960s.' The photograph is reproduced by courtesy of Rotherham Archives and Local Studies Service (no. 09276).

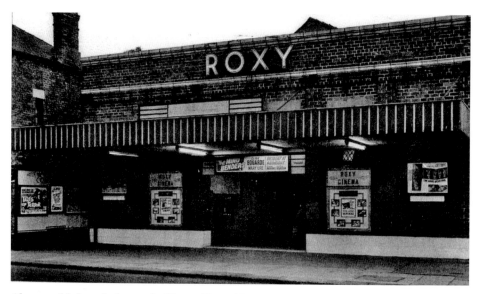

Above and below: **Swinton, the Picture House/ Roxy**

The Picture House, opening on 15 July 1929 with *Battle of the Sexes*, was built by Thomas Wade & Sons to the designs of architect P. A. Hinchcliff. The cinema had a stadium-style auditorium and a total seating capacity of 904. It was equipped with the last Clavorchestra Organ, built by Brindley & Foster of Sheffield. After passing to the Mexborough Theatre Circuit, it reopened as the Roxy Cinema on 2 August 1937. The cinema eventually became part of the Star Group of Cinemas and CinemaScope was installed in June 1955, with *The Student Prince* being the first film shown. From July 1961 bingo was introduced on Sundays, then took over full-time, but full-time cinema returned for a time until the Roxy closed on 3 April 1965 with *The Magnificent Showman*. In time it became a skateboard centre, then a squash club, and is presently known as Café Sport. The top picture is reproduced by courtesy of Sheffield Newspapers; the one below was taken on 31 July 2011.

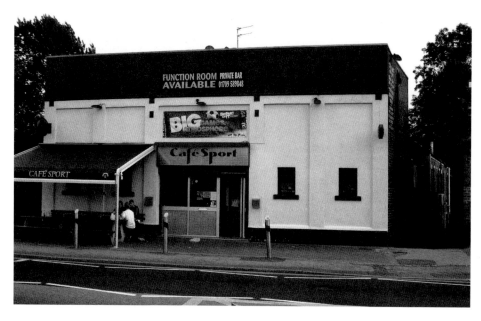

Thurcroft, Picture House

Alan Wade, on www.rotherhamweb.co.uk, states: 'The picture house [known as the Woodhouse Green Cinema] was opened just after the end of W.W.1., it cost 1*d* and a jam jar to get in, jam jars were recycled. Between W.W.1. and by the 30's the two shops either side of the picture house doorway were a sweet shop run by a Mrs Ethel Leighton and on the other side a grocers run by Mrs. Elizabeth Lewis. I can remember the sweet shop, I went in there as late as the 1970's, not sure when it closed as a sweet shop, it was lovely, very old fashioned looking, today it's a hairdressers and the other shop is a sandwich shop.' Thurcroft Cinema later became an auction house. The photograph was taken on 31 July 2011.

Wath, Majestic

Built by local builders Thomas Wade & Son, the Majestic Cinema Theatre opened on Monday 2 August 1926. Inside the building was a proscenium opening of 25 feet with a height of 22 feet, and the stage had a depth of 40 feet. There were eight dressing rooms and a spacious pit in front of the stage could accommodate a full orchestra. Seating was for 1,089 in the latest tip-up style, and adjoining the balcony at first floor level was a small café. The first talkie was shown on Tuesday 29 April 1930 and a wide, panoramic CinemaScope screen was installed in March 1955. The cinema closed on 7 July 1956; *King's Rhapsody*, starring Anna Neagle, was the last film screened. After lying redundant for a number of years, the building was demolished in the early 1970s and a retail store was built on the site. The photograph is reproduced by courtesy of Rotherham Archives and Local Studies Service (No. 12972).

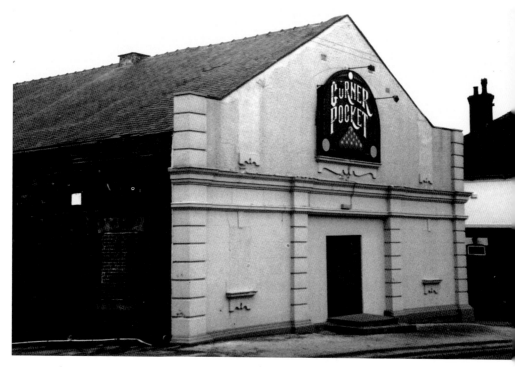

Wath, West Melton, Grand Cinema, Norton Road

The Grand Cinema was opened by the West Melton Cinema Company on 24 March 1913. It seated around 600 and the first manager was Frank Parr. Cine/variety was introduced from 26 April 1913, leading to the building being titled The Grand Variety and Picture Theatre. The premises underwent considerable alterations in 1929/30. These were carried out by Conisbrough contractors H. Cooper & Sons to the designs of B. Dean of Mansfield. Sound was introduced on 4 August 1930, with *Disraeli* and *The Hottontot*. Further modernisation occurred in 1954, when the building became part of the Star Group. CinemaScope was introduced in 1955 with *The Student Prince*. Bingo was introduced on certain days from June 1962 and closure as a cinema came on 23 March 1963. The last film to be shown was *The Notorious Laundry*. Bingo flourished until the 1970s, when the building, after a period of neglect, became a snooker club in 1995. The photograph is reproduced by courtesy of Rotherham Archives and Local Studies Service (No. 14364).

Sheffield

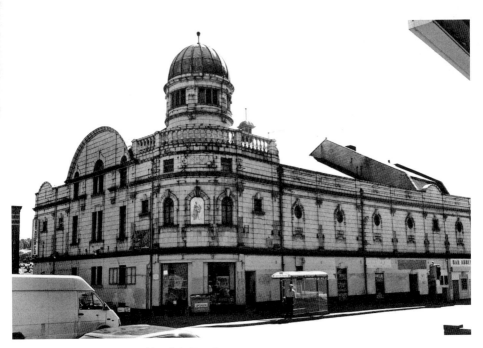

Abbeydale Picture House, Abbeydale Road
Designed by Dixon & Stienlet of North Shields, the Abbeydale Picture House opened on 20 December 1920 with a striking exterior clad in white faiance tiles and a corner entrance dominated by a large open dome tower. Inside, the seating was arranged in stalls and circle levels, with the circle extending along the side-walls towards the proscenium opening. In September 1921, a large ballroom and billiard hall opened in the basement. 'Talkies' arrived at the Abbeydale on 10 March 1930, with Janet Gaynor in *Sunny Side Up*, and it was taken over by Star Cinemas Ltd in the 1950s, becoming known as the Abbeydale Cinema. Closure came on 5 July 1975 with *Breakout* and *Lords of Flatbush*. A. & F. Drake, Office Furnishers, used the building as a furniture showroom until they ceased trading in 1991. Earlier, in 1989, the Abbeydale Picture House was designated a Grade II listed building by English Heritage. Early in 2006, a community group took over the building and began using it as a performance space. Photograph reproduced by courtesy of Sheffield Newspapers.

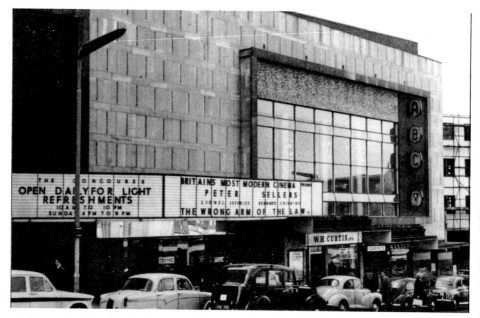

Above and below: ABC, Angel Street

When the ABC opened on 17 May 1961 with *Don't Bother to Knock*, it was one of the most modern cinemas of its day, fully equipped with 70mm facilities and a six-track stereophonic sound system with a 60-foot-wide screen. Built in a stadium style, where the circle was slightly raised from the stalls, the total seating capacity was 1,327. A cafeteria area known as the Concourse, with large windows looking out onto Angel Street, was converted into a ninety-four-seat mini-screen cinema and opened on 21 September 1975. The ABC passed into the Cannon Group's hands when they took over the ABC circuit in May 1986, and was renamed Cannon in January 1987. The cinema closed on 28 January 1988 and was demolished the following year. The site was a car park for over ten years and is presently occupied by a hotel and shop.

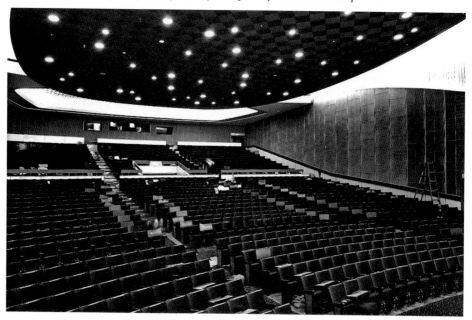

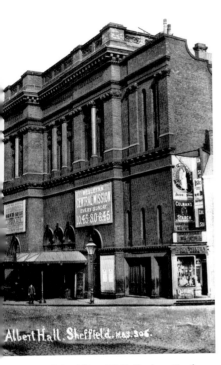
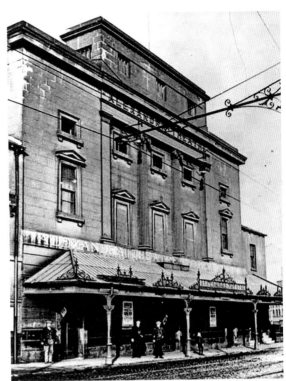

Above left: Albert Hall, Barkers Pool

Built to a design by Flockton & Abbott, the Albert Hall was on the site of the former Quaglen's Circus and opened as a concert hall on 15 December 1873. A small hall, chapel and dressing rooms were on the ground floor, while the main auditorium was on the first floor and was made up of a salon (stalls), a balcony of three sides with a second tiered balcony and an upper gallery above. At the rear of the open stage was an organ built by Parisian Cavaille-Col. Animated pictures were shown from September 1896, followed by many showmen visiting the venue with short films. New Century Pictures acquired the Albert Hall in 1919 and converted the building into a full-time cinema. New Century Pictures were absorbed by the Gaumont British Picture Corporation, and in June 1927, employing architects Chadwick & Watson, the company refurbished the building. Seating was reduced to 1,611 and the first sound film, *Weary River*, was shown using the Western Electric Sound system. On 14 July 1937, fire gutted the building and the shell was left standing for a number of years. After the Second World War the land was bought by Sheffield Corporation and eventually the Cole Brothers department store was built on the site in around 1963.

Above right: Alexandra Theatre, Blonk Street

The Adelphi Theatre was built to the designs of a Mr Egan on the Furnival Street/Blonk Street corner in 1837. On www.chrishobbs.com, it is stated: 'The building was based on the Astley's famous amphitheatre in Westminster Bridge Road, London. Boasting a 42-foot diameter ring, the theatre could be transformed into an arena capable of hosting a variety of circus acts. In fact the building was originally known as The Circus (or Adelphi Circus)'. In 1865, it was acquired by Thomas Youdan and converted into the Alexandra Music Hall. The theatre closed on 28 March 1914. *The Bonnie Pit Lad* was the last production, and the building was demolished shortly afterwards.

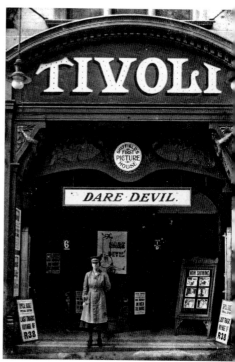

Above left: **Britannia Theatre, West Bar**
The Britannia at 121 West Bar dated back to before 1860 and had a seating capacity of about 1,000. The Britannia was run by Louis Metzler. Bryen Hillerby, in *The Lost Theatres of Sheffield* (1999), records: '... the introduction of basic fire regulations caused the Britannia to close in 1895.' The building was later converted for other purposes, and after being damaged by fire was demolished. Photograph reproduced by courtesy of Sheffield Newspapers.

Above right: **Central Hall/Tivoli, Norfolk Street**
The building opened in 1899 (for services and youth activities) and was used as a cinema, the New Central Hall, by Jasper Redfern from 10 July 1905. After closing for alterations, the building reopened on 9 December 1912, and became the New Tivoli from 12 January 1914. Fire damage disrupted activities between November 1927 and July 1928. In the following decade a Western Electric sound system was installed and because of a penchant for screening cowboy films, the Tivoli was popularly known as 'the Ranch.' The curtain finally fell on the cinema as a result of bomb damage on 12/13 December 1940.

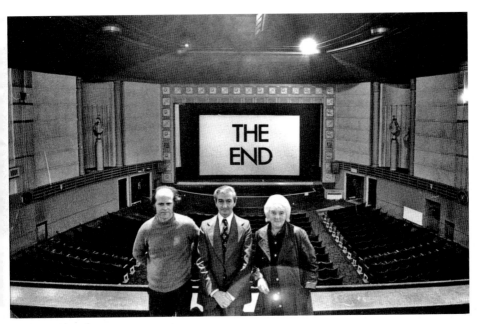

Above and below: **Capitol Cinema/Essoldo/Vogue, Barnsley Road**

Opening on 18 September 1939, the Capitol Cinema, designed by George Coles and built by M. J. Gleeson Ltd, could seat 1,716, including 500 in the circle. The first film was *Angels with Dirty Faces*. The proscenium was 36 feet in width, and there were four dressing rooms, which were put to good use during the Second World War, when Sunday concerts featured a number of noted musical hall stars. The Capitol was taken over by the Essoldo chain in November 1949, becoming known as the Essoldo in April 1950. During the first half of the decade 3D films were featured and CinemaScope and stereophonic sound were installed. Essoldo Cinemas were absorbed by the Classic chain in April 1972 and the cinema was renamed Vogue. Closure came on 4 October 1975, and the building initially housed the Crown Bingo Club, and later a furniture warehouse. The top picture was taken on 4 October 1975 and is reproduced courtesy of Sheffield Newspapers. The one below was taken on 7 August 2011.

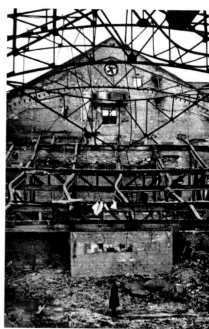

Above, left and right: **Central Picture House, The Moor**

The Central Picture House, designed in Neo-Grecian style by J. Mansel Jenkinson, opened on 30 January 1922, seating 1,600: 1,000 in the stalls and 600 in the circle. There was a waiting hall for 500 patrons, a smoking room and lounge on the ground floor and a café-restaurant on the second. In the basement there was a large billiards room with sixteen tables. In 1929 the Central took over the Sunday Services which had been previously held in the chapel at the Albert Hall, but these ceased in 1935.The Central Picture House and the Regent Theatre were the first Sheffield cinemas to show talkies, on Monday 17 June 1929 – the Regent Theatre with *Showboat* and the Central Picture House with *The Singing Fool*. During the blitz of 12/13 December 1940 the cinema was damaged by enemy action over the city and it never reopened. A caption on the reverse of the picture on the right states: 'People stayed on to watch the movie while the bombs dropped and only evacuated when the roof caught fire'. The last films shown were *The Bluebird* and *That's The Ticket*. The building was finally demolished when the Moor was redeveloped during the early 1960s.

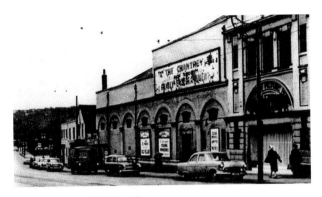

Chantrey Picture House, Chesterfield Road

Built by M. J. Gleeson, the Chantrey Picture House featured a series of brick arches along the Chesterfield Road frontage and a terracotta entrance façade. It opened on 22 May 1920 with *The Crimson Gardenia* and a Charlie Chaplin short. Seating was for 1,400 in stalls and balcony, and a Clavochestra organ was installed to provide background music during 'silent' films. Adjacent to the cinema were tea rooms and a ballroom, later used as a billiard hall. *Sunnyside Up* was the first talkie screened at the Chantrey on 28 April 1930. Further alterations to the building took place at the end of the decade and CinemaScope was introduced in February 1955. Closure came on 28 February 1959 with the films *The Young Invaders* and *The Outlanders*. The builders Gleesons took over the building for office accommodation until it became a restaurant. Photograph reproduced courtesy of Sheffield Newspapers.

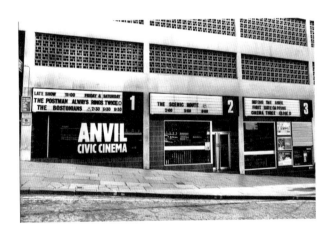

Cineplex/Anvil, Charter Square

Retired Rank Organisation official David Williams opened and managed the Cineplex Three Screen Cinema from 31 January 1972. It occupied three shop units within the Grosvenor House Hotel complex on Charter Square. Cinema 1 seated sixty-five, Cinema 2 seventy-six, and Cinema 3 had a capacity of 110. Initially all three screens were fitted with 16mm projection facilities, which restricted the number of films that could be shown. In 1983, David Williams ended his association with the complex and the venture closed. Sheffield City Council took over and ran the building as a municipal arts cinema and it reopened on 31 March 1983, and was renamed the Anvil Civic Cinemas from 6 October 1983. As may have been expected, given the political climate in Sheffield at that time, the venture courted much criticism from opposition groups. In 1985, 35mm projection equipment was installed for the third screen and other improvements were made. But, probably bowing to pressure, the Council closed the complex on 3 November 1990. The building is presently occupied by an Indian restaurant.

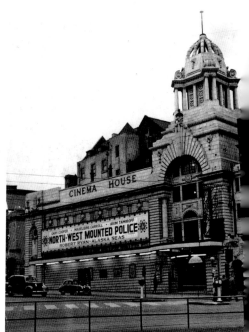

Above left: **Cinecentre, Pond Street**
Leslie Elliott of the Compton Cameo Group of Companies opened the Cinecenta Twin cinemas on 30 January 1969, in the Pond Street development and below the Fiesta Nightclub. The company policy was to show films that were not on the major circuits and a small number of cinemas were opened around the country. Sheffield's Cinecenta 1 seated 144, and Cinecenta 2 seated 190. The two small projection rooms used the mirror periscope system with Phillips FP20 projectors. On 30 March 1969, Cine 2 became the Penthouse CineClub (a private members club), screening uncensored films. By October 1969 both screens were 'Members Only' cinemas. The members only/open to the general public systems fluctuated for a number of years, and in 1980 the Star Cinemas chain acquired the small Cinecenta circuit. This, in turn, was taken over by the Cannon Group in 1985. A year later the Cinecentas were renamed the Cannon Flat Street Cinemas and both screens showed films on general release, but closure with Cannon came in 1989. Rank Theatres reopened the cinemas as the Fiesta Twins in August 1989, but they were closed in September 1991 and incorporated into the Odeon Cinema complex. The photograph was taken on 17 September 1985 and is reproduced courtesy of Sheffield Newspapers.

Above right: **Cinema House, Fargate/Barker's Pool**
The Cinema House, with a glazed white faience façade and a tower above the cinema entrance, was opened on 6 May 1913 by the Sheffield & District Cinematograph theatres Ltd. Designed by J. H. Hickton and H. E. Farmer in a Classical style, the building was erected by George Longden & Son Ltd of Sheffield and seated 800. The Cinema House opened with *Theodora* and *Construction of the Panama Canal*. BTH sound equipment was installed in February 1930 and the first sound film shown was *Climbing the Golden Stair*. The cinema was fortunate to escape damage in the Blitz when a bomb exploded a short distance away in 1940. In 1959, the cinema was sold to property developers and the final show on 12 August 1961 featured *The Horse Soldiers* and *The Devil's Disciple*. The Cinema House was then demolished.

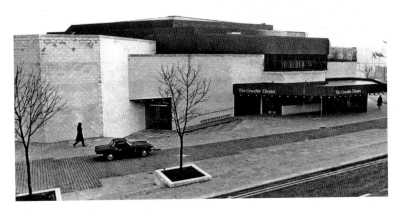

Crucible Theatre, Norfolk Street

Designed by Tanya Moiseiwitsch, the Crucible Theatre opened in 1971, replacing the Playhouse Repertory theatre in Townhead Street. Seating 980, it features a thrust stage. The opening performance in November 1971 featured 'Fanfare', an evening's entertainment comprising: children participating in an improvised scene, Chekhov's *Swan Song* with Ian McKellen and Edward Petherbridge and a Music Hall Finale with a Sheffield brass band. In 2001 the Crucible was awarded the Barclays Theatre of the Year Award, and is a Grade II listed building. The building went through a £15 million refurbishment between 2007 and late 2009. The World Snooker Championship tournament has been played annually in the Crucible since 1977. The venue has also hosted championships of other indoor sports, such as table tennis and squash. Photograph reproduced courtesy of Sheffield Newspapers.

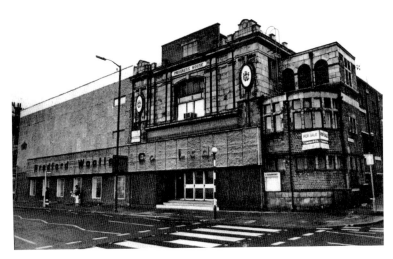

Don Picture Palace, West Bar

The architect for the Don Picture Palace was Henry Patterson and its doors opened on Monday 18 November 1912 with *Captain Starlight* and *Monarchs of the Prairie*. Plasterwork and decoration was by J. L. Harrison of Sheffield and the Don initially seated 950 on one level, but when the roof was raised in 1914 and a balcony added, this provided seating for an additional 350. Sound was introduced at the Don in April 1930, the British Acoustic system being adopted, and was updated in 1934 and replaced in 1944. Further improvements were made at the Don in 1956, but on 1 March 1958 it closed; the final films were *The Oklahoma Man* and *Footsteps in the Night*. The building is currently in existence and is used for commercial purposes.

Left and below: **Electra Palace/News Theatre/Classic**
Designed by J. H. Hickton & H. E. Farmer and constructed
by George Longden & Son Ltd for the proprietors, Sheffield
& District Cinematograph Theatres Ltd, the Electra Palace
opened on 10 February 1911. The extravagant exterior, in
white glazed terracotta, owed much to fifteenth-century
Arabic architecture; the interior seated 670. The first sound
film screened was *Movietone Follies of 1929*, on Monday
6 January 1930. Closing for alterations on 29 July 1945, the
cinema reopened as the News Theatre on 9 September 1945
under the new owners, Capital & Provincial News Theatres.
A further name change occurred on 15 January 1959, when
it became the Cartoon Cinema, showing continuous cartoons
and news films. On 15 January 1962, it was absorbed by the
Classic Cinemas chain and an extensive face lift occurred:
metal cladding covered the exterior, seating was reduced to
484, and the name was changed to Classic Cinema. Under
the control of the Cannon Group, which took over the
Classic chain in April 1982, the Classic closed on
24 November with *Rocky III*. Amid efforts to list the
building, it was destroyed by fire on Wednesday 15 February
1984, the remains being demolished. The bottom picture was
taken on 24 November 1982 and is reproduced courtesy of
Sheffield Newspapers.

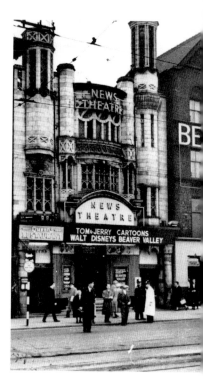

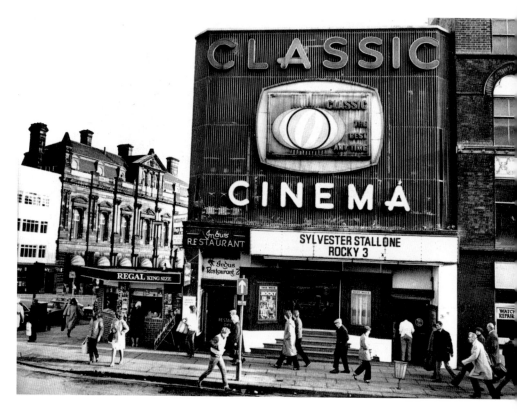

Right and below: **Empire Theatre, Union Street**
Designed by Frank Matcham and built for and
run by the Moss Empires chain of theatres, the
Sheffield Empire Palace Theatre of Varieties
was opened on Monday 4 November 1895
with seating for 2,500. A year later, and using
a Variety Lumiere Cinematographe, the Empire
was showing 'animated pictures' between
performances by all the old music hall favourites:
Marie Lloyd, Florrie Ford, George Formby,
Grace Fields, Ivor Novello, Jimmy Clitheroe,
Ken Dodd and Shirley Bassey. A fire broke out
in the building on 3 August 1942, and it did not
reopen until 6 September 1943. Also, during the
Second World War certain alterations were made
to the building's appearance, but in the following
decade the Empire became renowned for staging
large American musicals. Moss Empires sold
the Empire Theatre to an Edinburgh property
company in 1959, and after closing on Saturday
2 May it was eventually demolished and the site
redeveloped.

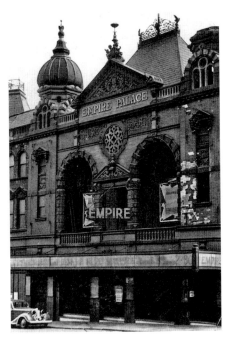

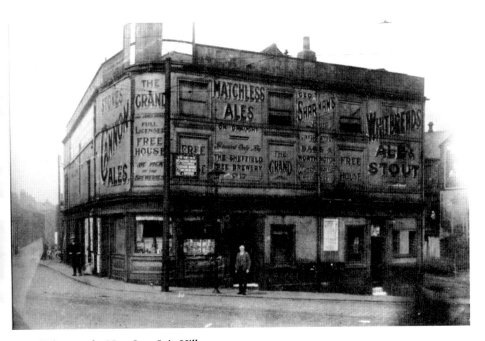

Grand Theatre, the New Star, Snig Hill
After extensive alterations, the New Star Music Hall, attached to a public house, opened as the
Grand Theatre in 1887. Further alterations were carried out in 1893, and under noted music
hall proprietor Frank McNaghten's tenure animated pictures were shown at the Grand from
November 1896. Between about 1908 and closure in 1920 it mainly operated as a cinema.
Ambitious plans for the venue were subsequently mooted but never came to fruition, the building
eventually being demolished in 1938.

Above and below: **Greystones, Ecclesall Road**

On 27 July 1914, the Greystones Picture Palace opened its doors with *A Shot at Midnight*. Designed by J. P. Earle, the building was brick-built with stone dressings to the façade, and initially could seat 700. It was equipped with a stage for variety shows and a basement ballroom was opened in October 1914. Seating was increased to 820 in July 1920, when a new café was opened and the ballroom extended. After installation of a BTH sound system, the Greystones' first talkie was *Sunnyside Up* on 14 April 1930. The 1950s were notable at Greystones for CinemaScope being installed, a fire closing the building for five weeks, extensive redecorations and the laying of a new ballroom floor. Never opening on a Sunday, Greystones' screened its last films on Saturday 17 August 1968: *A Challenge for Robin Hood* and *Ringo and His Golden Pistol*. After closure, Greystones went the way of many other cinemas, becoming a bingo hall, with the ballroom being converted into Napoleon's nightclub. When fire gutted the building in 1982, it was demolished. The top picture was taken on 9 August 1979, the bottom one 27 November 1982. Both pictures reproduced courtesy of Sheffield Newspapers.

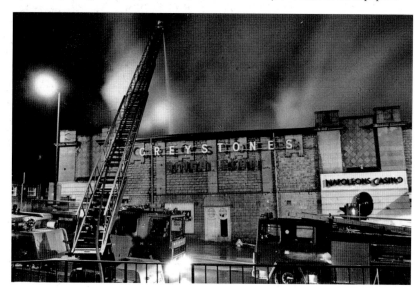

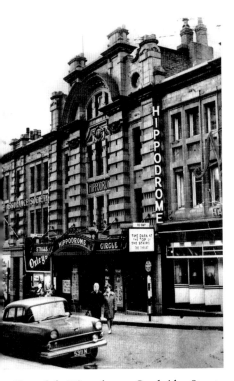 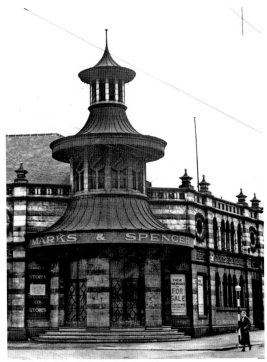

Above left: **Hippodrome, Cambridge Street**

Designed by Bertie Crew, the Hippodrome Theatre of Varieties opened on 23 December 1907 and came under Thomas Barrasford's Vaudeville Circuit. With a seating capacity of about 2,730, the auditorium comprised stalls, a circle, a gallery, and four boxes on either side of the proscenium arch. The opening night featured Barrascope pictures and, as with numerous theatres, animated pictures were included in the Hippodrome's programmes. In 1931 live theatre ceased, and under the tenure of ABC the building opened as the Hippodrome Cinema on 20 June 1931, with seating reduced to 2,445. The Western Electric sound system was used and the first films shown on a double bill were *Manslaughter* and *Social Lion*. In the ensuing years the Hippodrome underwent improvements in 1938, suffered bomb damage in December 1940 and was taken over by The Tivoli (Sheffield) Ltd in 1948. In the following decade CinemaScope was installed (1954), films were shown in 3D, a separate programme on a Sunday was run and the seating was reduced to 913 in the stalls and 506 in the dress circle – the gallery was redundant by 1959. Closing on Saturday 2 March 1963 with *Gone With the Wind*, the Hippodrome was demolished later in the year. The picture was taken on 30 November 1960 and is reproduced courtesy of Sheffield Newspapers.

Above right: **Lansdowne, London Road/Boston Street junction**

The Lansdowne Picture Palace, with a Chinese pagoda-style entrance and arched windows on the side elevation, was designed by Walter Gerard Buck. It opened on 18 December 1914 and originally seated around 1,250. In the silent era the Lansdowne boasted a 'Bijou' orchestra, and in the following years a canopy was added to the front entrance in 1937, the seating was reduced to 965 in 1940 and it closed on 12 December of that year. The final film was *Vigil of the Night*. Various uses were found for the building thereafter; it became a store for Marks & Spencers and a Mecca dance hall venue under the titles 'Locarno' and 'Tiffany's' and it presently forms part of a Sainsbury supermarket.

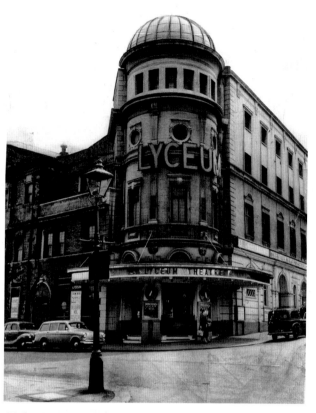

Lyceum Theatre, Tudor Street, now Tudor Square

Built on the site of the City Theatre, the Lyceum Theatre was opened on Monday 11 October 1897 by the Royal Carl Rosa Opera Company. It was designed by W. G. R. Sprague and is the only surviving theatre outside of London designed by him. The exterior features a corner entrance block topped by a dome tower and the auditorium some superb rococo plasterwork, two slightly curved cantilevered balconies, a proscenium arch with a rectangular moulded frame, and a cove ceiling with detailed plasterwork. Many of the major music stars of the day trod the boards of the Lyceum stage, besides other regular visitors, who included the D'Oyly Carte Opera, Sadlers' Wells Opera and the Royal Ballet. The Lyceum prided itself as being the home of Sheffield's pantomime. For many years, the months between Christmas Eve and Easter were panto time, with visiting producers bringing famous actors and variety turns to entertain local families twice a day. In the 1940s, the Lyceum began to produce its own pantomime and was attracting stars such as Morecambe and Wise, Harry Secombe and Frankie Howerd. During the 1960s the theatre's popularity waned. Installing cine equipment was considered impractical and in 1966 bingo was introduced during the summer months, with live theatre returning later in the year. By March 1969, the Lyceum was a full-time bingo hall, continuing until 1972, when the theatre was under threat of demolition. Fortunately this was resisted, and the theatre was designated a Grade II listed building. Various projects for the use of the building came and went, until the City Council bought the building in 1985 and it was reclassified to Grade II* listed status. Between 1988 and 1990 the Lyceum was completely restored at a cost of £12 million. The Lyceum Theatre reopened in December 1990, followed by a Christmas–New Year season with the Broadway version of *The Pirates of Penzance*. Pantomime returned to the Lyceum the following year and it now serves as a venue for touring West End productions and operas by Opera North. Presently it is run by a Trust, along with the adjacent Crucible Theatre.

Manor, City Road

Expected to serve the housing estates in Sheffield's Manor district, the Manor Cinema opened on 12 December 1927. Owned by Manor Picture House Ltd, it was built by M. J. Gleeson and seated 1,680. The façade was faced with rustic brick and included wide bands of coloured cement rendered dressings. The 'Manor Cinema' name was in the brickwork above the entrance doors; the auditorium, classical in style, seated 1,680. There was a billiard hall in the basement and sound was introduced in 1930. In subsequent years, further improvements to the exterior took place and the projection and sound equipment was updated. In 1956 the cinema was taken over by the Star Cinema Circuit, who introduced Children's Saturday Matinees along with Sunday openings. The Manor Cinema featured a mixture of films and bingo until final closure came on 14 June 1969, with a showing of *Candy* and *Round the Bend*. The building still stands and is a supermarket.

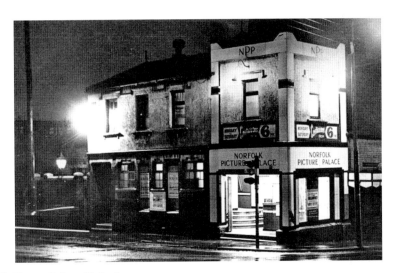

Norfolk Picture Palace, Duke Street

Opening on 24 December 1914, with a single-level auditorium seating about 1,000, the Norfolk Picture Palace was designed by Edmund Winker & Co. and owned by Norfolk Picture Palace Ltd. *The Rainbow Man* was the first talkie shown there, on 23 December 1929. The Norfolk was modernised in 1937 and its first CinemaScope film, *Three Coins in a Fountain*, was screened in April 1955. Surviving until 24 December 1959, the last films to be seen were *The Wings of an Eagle* and *The High Cost of Living*. The building was later demolished.

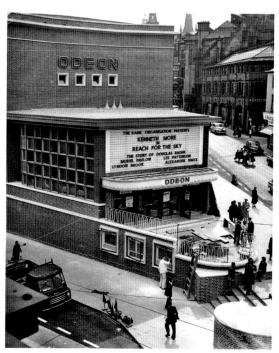

Odeon, Flat Street

Construction work was halted on a new 2,326-seat Odeon designed by Harry Weedon and W. Calder Robson when war broke out in 1939. Work restarted after the cessation of hostilities, but didn't include the projected offices and shops. The new cinema opened on 16 July 1956 and included 1,505 seats in the stalls and 814 in the balcony. The first film was *Reach for the Sky*. Todd-AO equipment installed at the Odeon allowed the screening of *South Pacific*, *Cleopatra* and *The Sound of Music*. Closure came on 5 June 1971 and it reopened as a Top Rank bingo hall, now Mecca bingo hall.

Odeon, Arundel Gate

The seven-screen Odeon opened on 5 March 1992. Five of the seven screens were fitted into the shell of the former Fiesta nightclub, the other two in the former Cinecenta auditoriums. Two additional screens were added in December 1994, and three years later a tenth screen was added. Seating in the various area ranges from 253 to 115.

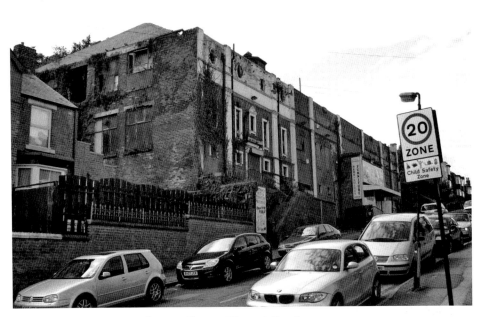

Above and below: **Page Hall/Roxy Cinema, Idsworth Road**

The Page Hall Cinema was opened on 24 May 1920 with a total seating capacity, including the balcony, of about 1,300. By 1929, the cinema included a café, billiards room and a ballroom. Sound was introduced in November, and the cinema was renamed Roxy after becoming part of the Buxton Theatres Circuit in November 1945. A year later, it was operating under Reiss (Cinemas) Ltd. Fire damage closed the cinema between January 1958 and June of that year. It reopened with the first CinemaScope film to be shown there, *The Bridge on the River Kwai.* After closing in June 1958 it reopened as a bingo hall, but currently houses a furniture warehouse. The top picture was taken on 7 August 2011, the one below on 6 June 1958 and is reproduced courtesy of Sheffield Newspapers.

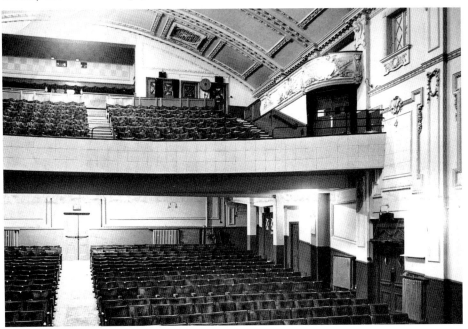

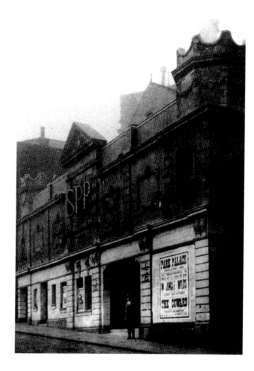

Park Picture Palace, South Street
Built with a white faience
frontage by Henry Boot & Sons
Ltd, the Picture Palace opened on
2 August 1913, seating around
800. It closed in June 1962, but
was reopened in November 1963
by Dennis O'Grady. Final closure
came on 31 December 1966 with
the films *Peter Pan* and *Emil
and the Detectives*. It reopened
as a bingo hall but was later
demolished.

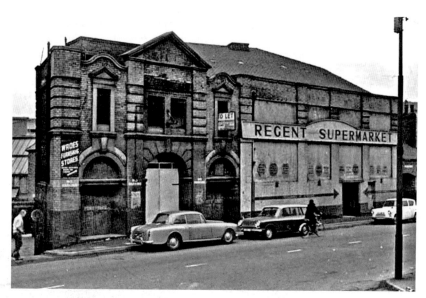

Picturedrome, Upwell Street
The Picturedrome opened on 18 March 1912 with seating for around 700. Later
in the year variety was included in the weekly programmes, and on 4 May 1925 it
was reopened as the Regent Theatre. Sound was installed in about 1930, and two
years later the premises were in the hands of the Barnsley Electric Theatre (later
Regent Varieties) Sheffield, running variety and revue shows from May 1935. The
Picturedrome/Regent closed on 15 June 1940. Photograph reproduced courtesy of
Sheffield Newspapers.

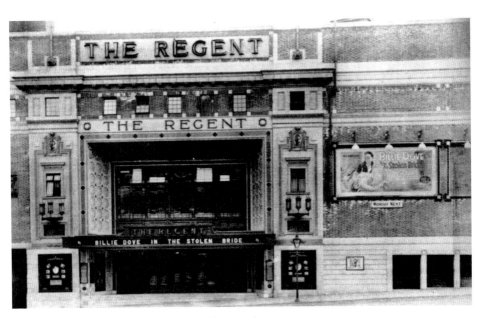

Above and below: **Regent/Gaumont, Barker's Pool**

Built by McLaughlin & Harvey for the Provincial Cinematograph Theatres circuit (PCT), the Regent Theatre opened on 26 December 1927. It was designed by architect William Edward Trent and seated 1,450 in the stalls and 850 in the balcony. The neoclassical-style auditorium featured a double dome in the ceiling and had full stage facilities. On the opening day there were three performances of *My Best Girl*; sound was installed by 17 June 1929 and the first film shown was *Show Boat*. Gaumont British Theatres absorbed PCT in February 1929, but the Regent was not renamed Gaumont until 27 July 1946. During the 1960s the stage was used by headlining acts such as The Rolling Stones and The Beatles. In the following decades twinning occurred in 1969 and a third screen was added in 1979. The Gaumont closed on 7 November 1985 and a new Odeon twin cinema was built on the site, opening in 1987. However, this was short-lived as the Odeon closed in 1994 and the building presently accommodates a nightclub. The bottom picture was taken on 4 November 1985 and is reproduced courtesy of Sheffield Newspapers.

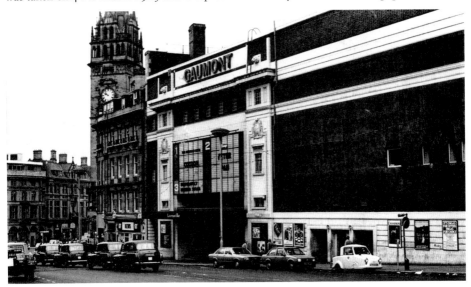

Roscoe Picture Palace, Jobson Road/Infirmary Road junction
The New Roscoe Picture Palace, replacing an earlier establishment titled the People's
Electric Palace/Roscoe, opened on 17 April 1922. Including the balcony, it seated
about 900 and showed its first talkie in October 1930. CinemaScope was introduced
in September 1955, and the Roscoe toyed with bingo sessions under several tenants
from 1961 to 1962 before final closure as a cinema on 22 April 1962. Bingo then took
over for a time, and later the building was demolished. Photograph by Richard Ward.

Scala, Brook Hill/Winter Street junction
Designed by G. B. Flockton with an Italianate façade featuring a portico entrance, the
Scala was opened on 23 December 1921. Seating about 1,020, the Scala's first film
was *Let's be Fashionable*; the first talkie, on 21 October 1929, was *Broadway Melody*.
The building suffered bomb damage in December 1940, closed in July 1952 and was
demolished twelve years later.

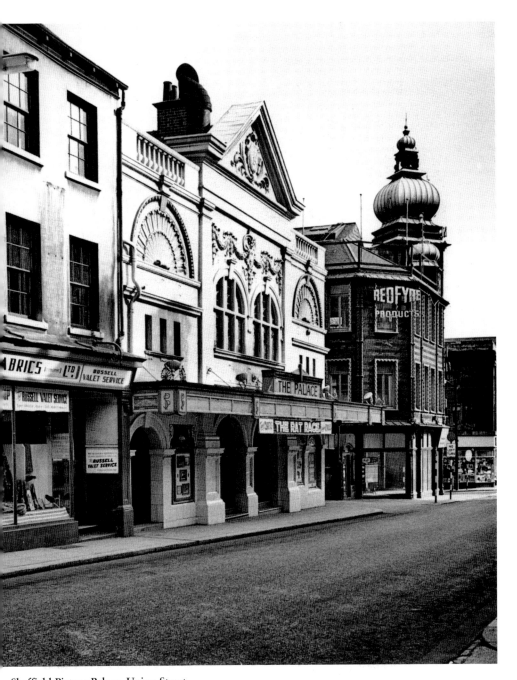

Sheffield Picture Palace, Union Street

Len Shaw was the Sheffield Picture Palace manager from when it opened on 1 August 1910 until his death forty-four years later. Designed by Benton & Roberts and built by George Longden & Son Ltd, the Palace had a white faience frontage and seated 1,000 in the stalls and balcony. Following unsuccessful experimentation with cine-variety in 1929, sound was installed at the Palace shortly afterwards. During the 1950s, the Palace was noted for showing films in CinemaScope and closed on 31 October 1964. Later, the building was demolished. Photograph taken by Colin Farrant on 9 July 1961.

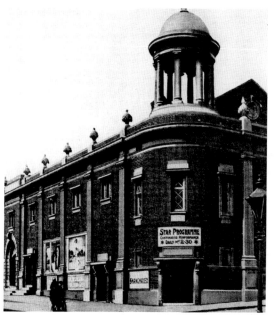

Star Picture House, Ecclesall Road
Opening on 23 December 1915 with a seating capacity of 1,028, the Star's first film was *Marguerite of Navarre*. Run by Sheffield Premier Pictures Ltd, the Star's first talkie using Western Electric sound equipment was *Under the Greenwood Tree*, shown on 23 December 1929. The building suffered bomb damage during the Second World War, and was taken over by the Star Group in 1955. The last films shown at the Star were *Voyage to the Bottom of the Sea* and *Dossier*, on 17 January 1962. The premises survived as a bingo hall until 1984 and were demolished two years later.

Showroom, Paternoster Row
The Showroom Cinema is an 'independent', and first opened in 1993 with two screens; further phases of development have added another two screens, a bar and café and a meeting room. Much of the remainder of the building is the Workstation, offices intended for use by business working in the 'cultural industries'. The conversion programme was completed in 1998 and saw an entrance to the cinema created from Sheaf Square; the Workstation retains the original entrance on Paternoster Row. In 2002, the cinema was voted the favourite independent cinema of *Guardian* readers. The photograph was taken on 9 August 2011.

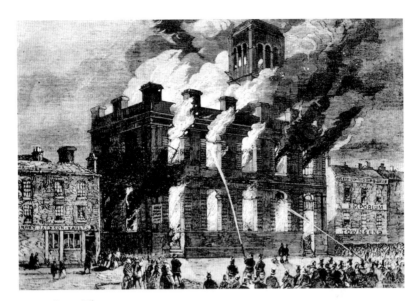

Surrey Street Theatre
The Surrey Street Theatre was opened and developed by Thomas Youdan in
c. 1860 and in time accommodated about 1,500 people. The building was
destroyed by fire on 25 March 1865.

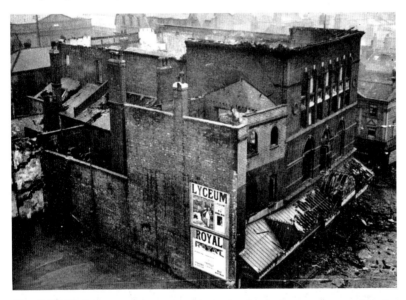

Theatre Royal, Tudor Street
Standing opposite the present Lyceum Theatre site and close to the site of the modern Crucible
Theatre, the Theatre Royal originally opened in 1763. Fourteen years later it was demolished and
rebuilt, reopening in 1778. The name alternated between both Theatre and Theatre Royal. Major
alterations occurred in 1855 and 1901, when Frank Matcham was in charge of redecoration and
improvements. This included the stage being enlarged, new dressing rooms added and electric
lighting was installed. The seating capacity was around 2,500 and the proscenium opening was
28 feet wide with a stage depth of 39 feet. The theatre was destroyed in a fire on 30/31 December
1935. The photograph was taken on 31 December 1935.

Left and below: Wicker Picture House/Studio 7, the Wicker

With a white faience exterior and a parapet topped with Grecian urns, the Wicker Picture House opened its doors on 14 June 1920. Including the circle, the seating was for around 1,080 and the first film shown was *Broken Blossoms*. BTH sound equipment was installed in 1930 and the first talkie, *The Jazz Singer*, was shown there on 5 May. Leased to the J. F. Emery Circuit in the 1930s, it was closed between December 1940 and April 1941 after suffering bomb damage. The cinema was part of the Star Group by the 1950s and was renamed Studio 7 on 15 October 1962; the frontage also underwent alterations at this time. Thereafter, the cinema concentrated on showing mainly X-rated films, but fire damage closed the building for a period in the late 1960s. In 1967 a new Vistarama floating screen was installed, and during 1974 the cinema was provided with triple screens, becoming titled Studio 5-6-7, and opened on 7 April. Closure came for a period on 14 December 1982, but it was reopened by a private company from 18 April 1986 to 20 August 1987. The building was demolished in the 1990s to facilitate the new Sheffield Ring Road scheme. The bottom picture was taken on 29 August. 1962. Both pictures are reproduced courtesy of Sheffield Newspapers.

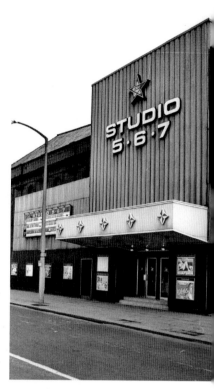

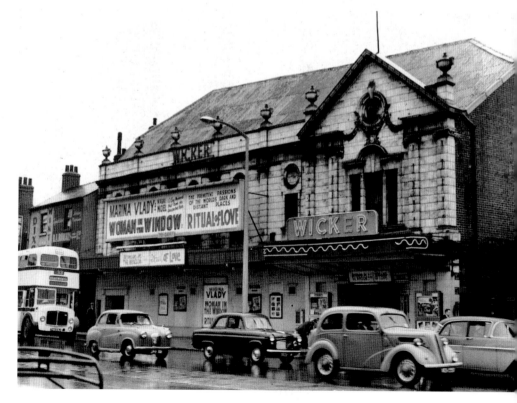

Sheffield District

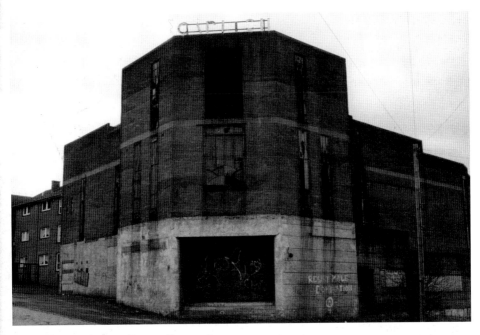

Arbourthorne, Carlton Cinema, Eastern Avenue

The Carlton Cinema opened on 15 August 1938 and seated 1,222, with 351 in the balcony. It was designed by Fowler & Marshall and built by W. G. Robinson Ltd for the owners, Sheffield & District Cinematograph Theatres Ltd. The Carlton opened with *King Solomon's Mines* and was allegedly the first all-concrete cinema, displaying a rather bland and unpleasing frontage. The *Sheffield Telegraph* reported that it was capable of withstanding the effect of a medium-sized bomb! Albert Burrows was the manager throughout the cinema's lifespan and it never opened on Sundays. Surviving a mere twenty-one years, the Carlton closed on Saturday 7 February 1959 with *King Creole*, and after being adapted for commercial use it was eventually demolished. The photograph was taken on 26 February 1993 and is reproduced courtesy of Sheffield Newspapers.

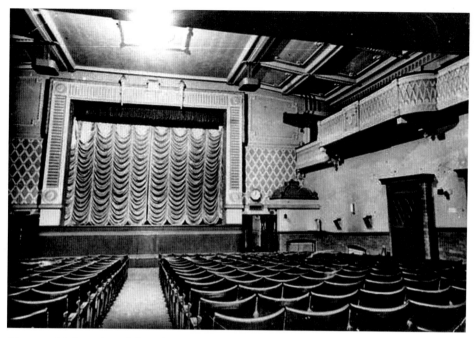

Above and below: Attercliffe, Adelphi, Vicarage Road

W. C. Fenton designed the Adelphi Picture Theatre, which was opened by the Adelphi (Sheffield) Ltd company on 18 October 1920, seating around 1,350. The opening programme included the film *Auction of Souls*, and in the early days at the venue variety acts appeared. Sound was installed in 1930; *Smiling Irish Eyes* was the first film shown. The Adelphi closed as a cinema on 28 October 1967, after showing *The Karate Killers* and *The Rounders*. Bingo thrived until around 1995, and thereafter it became a nightclub, then a teaching centre and has been designated a Grade II listed building by English Heritage. Both pictures are reproduced by courtesy of Sheffield Newspapers; the one below was taken on 9 January 1991.

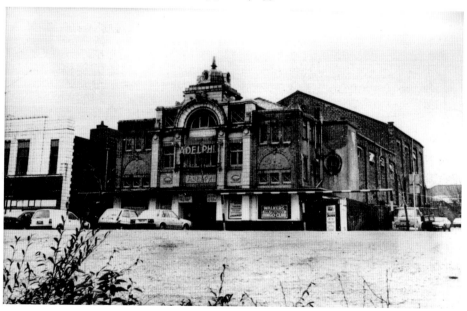

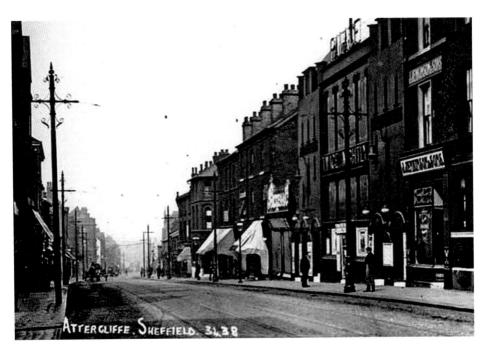

Above and below: Attercliffe, Attercliffe Palace

Designed by G. D. Martin and A. Blomfield Jackson, and erected by G. Longden & Son Ltd, the building opened on 3 January 1898 as the Alhambra Theatre of Varieties. Operated by the Alhambra Theatre Company, it seated 1,200 and was renamed Attercliffe Palace Theatre in 1904, showing its first films in June 1909 under the tenure of the Raymond Animated Picture Company. A further name change, to Palace of Varieties, occurred in November 1911. By October 1930 it had been redesigned by architect Fred A. Foster and a Western Electric sound system was installed, but a few variety acts still appeared. Seven years later it switched full-time to live theatre, the last film being *Sweet Aloes*. It closed on 1 July 1955 with the revue 'Strip, Sauce and Spice', and was demolished in 1962.

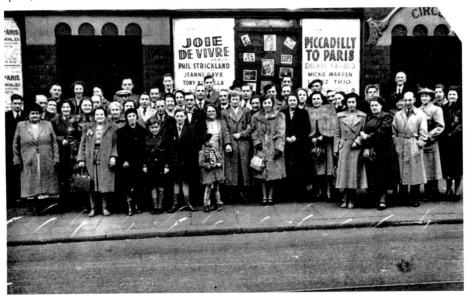

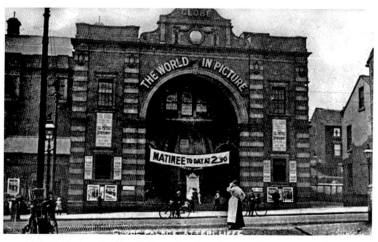

Attercliffe Common, Globe, Hill Top

Built by Longdens to Benton and Roberts' designs, which included a large dome over the main entrance, the Globe opened on 10 February 1913. In time it was controlled by Sheffield & District Cinematograph Theatres Ltd and seated 1,300 in the saloon and pit, with a further 400 accommodated in the balcony. Sometimes infamously known as the 'bug hut', the cinema's first talkie was *The Co-optimists* on 31 March 1930. It closed during June 1959 and was demolished.

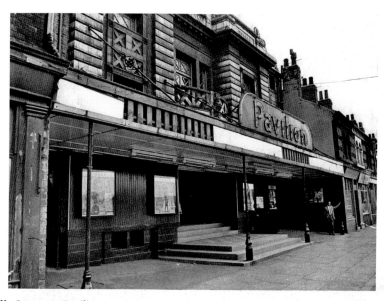

Attercliffe Common, Pavilion

Designed by Hickton & Farmer, the Pavilion opened on 23 December 1915 with seating for about 1,075. The first talkie shown there was *Broadway Melody* on 24 March 1930. Improvements were carried out in 1930 and 1955 (when the Star Circuit took control), and the building was used for bingo, roulette and films, with combinations, from 1961 until March 1970. Thereafter, Birmingham firm Elite Films showed a mixture of English and Asian films until October 1970. Asian films were then screened exclusively until 1979, and later the building was demolished. The photograph was taken on 20 August 1971 and is reproduced courtesy of Sheffield Newspapers.

Above and below: **Beighton, Central Hall, High Street**

Edwin W. Whitely opened the Central Hall on 7 August 1913 with seating for about 450. The building was destroyed by fire on 29 March 1922, and following rebuilding it reopened in September 1922, seating 500. Sometimes the venue hired variety acts instead of showing films. BTH Sound equipment was installed in May 1932, and later in the decade the cinema underwent alterations, which included increasing the seating to about 600. It was taken over by the Star Group in 1956, and before closure on 22 March 1963 had run a Saturday morning children's club and experimented with bingo sessions. It became the Central Casino for a period, and was then demolished.

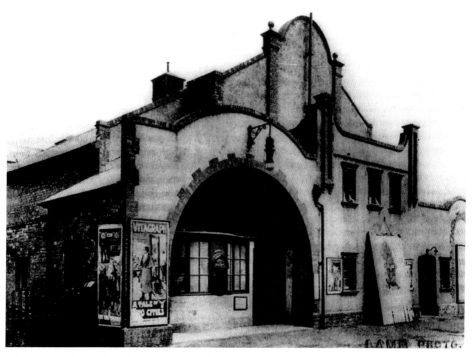

Above and below: Chapeltown, Picture Palace

The Picture Palace was a purpose-built cinema featuring a Moorish revival-style frontage. Designed by Benton & Roberts and built by George Longden & Son Ltd for the Chapeltown Picture Palace Ltd, the cinema opened on 23 December 1912, with seating for about 700, all on a single floor. Each autumn from 1925 to 1930 the Chapeltown Operatic Society used the building, which accommodated a large stage. Sunday opening didn't come until June 1956, and Friday evening bingo sessions ran from February to August 1962. Full-time cinema returned until closure on 16 March 1963. Three days later, it reopened as a Star Bingo Club & Palace Casino; the building is currently used as a snooker club, the Cue Ball. The bottom picture was taken by Richard Roper on 16 June 2002.

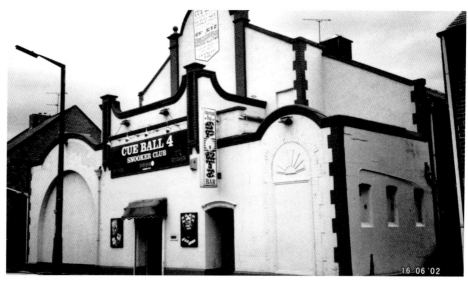

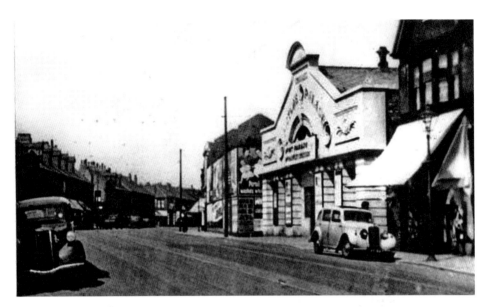

Crookes, Picture Palace

The Picture Palace, brick-built with a decorated cement façade, was designed by Walter G. Buck and constructed by Joseph Enoch. It was opened by the Crookes Picture Palace Ltd on 2 November 1912 and had a seating capacity of about 800, all on a single floor with a raised section at the rear. A Western Electric sound system was installed in June 1931 and CinemaScope in June 1956; the first film shown was *My Sister Eileen*. It closed on 2 April 1960 with *Babette goes to War* and *Senior Prom*. It was then converted to a supermarket.

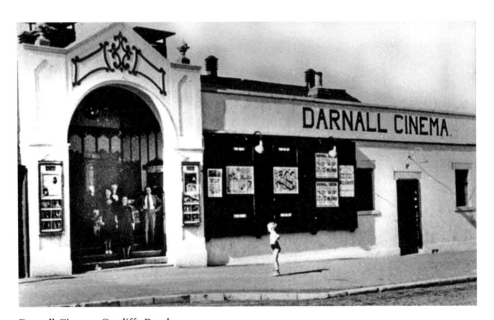

Darnall Cinema, Catcliffe Road

The Darnall Cinema, with an arched entrance, was opened on 15 December 1913 by local builder George Payling. Later it was leased to William Forsdike, and then purchased by William Brindley. The cinema closed on 2 December 1957.

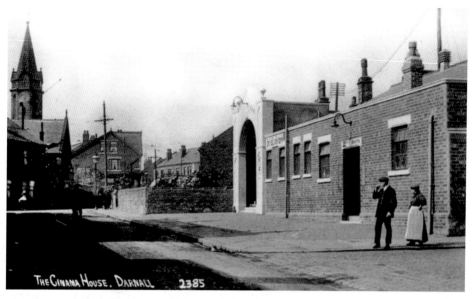

Exterior view of Darnall Cinema.

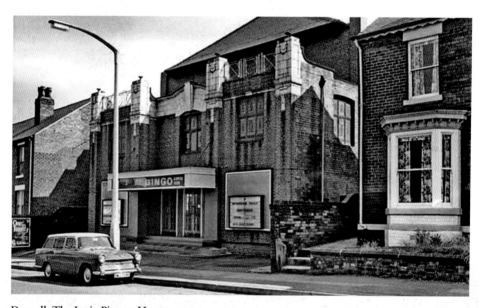

Darnall, The Lyric Picture House

The Lyric Picture House was opened on 22 November 1920 and, curiously, the screen was at the front end of the building and the balcony to the rear. Seating between 1,020 and 800 in the stalls and 220 in the balcony, the Lyric's first talkie was *Sunny Side Up* in 1930. The Lyric was taken into the Star Cinema Group in 1943 and CinemaScope was introduced in May 1955. From Sunday 27 May 1962, bingo took preference, first on Sunday nights then Wednesdays, until the last films were shown on 29 August 1962: *The Pot Carriers* and *Spin of a Coin*. Converting to a full-time Star Bingo Club, the Lyric Casino, this continued until the building lay derelict for several years and was finally demolished, the site taken for a housing development. Picture reproduced courtesy of Sheffield Newspapers.

Right and below: Darnall, Picture Palace/Balfour, Staniforth Road/ Balfour Road Junction

Incorporating a 'castle' design with small towers, the Darnall Picture Palace opened on 19 July 1913. Walter Buck was the architect and the building initially seated around 750. Following extensive alterations in 1920, the auditorium included a balcony and the total seating was raised to about 1,000. For a time the Picture Palace was run by Hallamshire Cinemas, a sound system was installed in May 1931, and instead of the name Picture Palace the building was sometimes referred to as the Balfour. The first CinemaScope film was shown in July 1956, and the last films were screened on 28 February 1959.

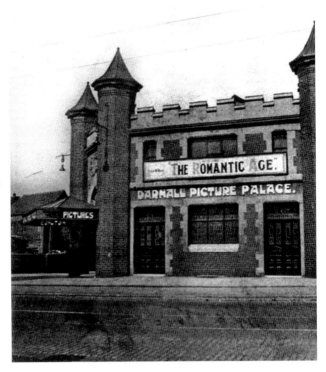

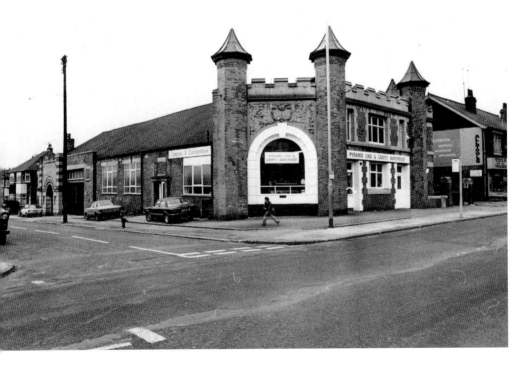

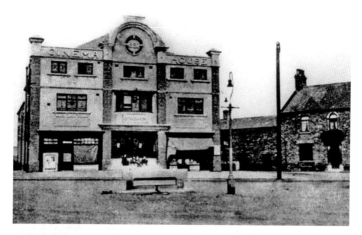

Ecclesfield Cinema House, The Common
The cinema was built and owned by Michael J. Gleeson, opening on
1 January 1921 with a seating capacity of 685, including 200 in the
balcony. Sound was introduced on 7 March 1932, when *King of Jazz*
was shown. The building was renamed Essoldo on 11 September 1950,
CinemaScope was introduced in 1955 and closure came on 7 February
1959 with *The Young Lions*. Demolition followed thereafter.

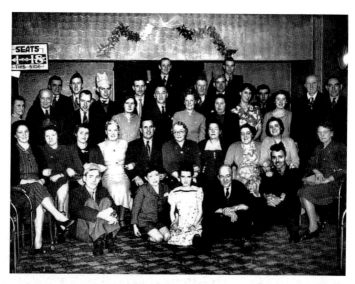

Firth Park Paragon, Paragon Cinema, Spicey Avenue
The Paragon Cinema, Sheffield's first new cinema to appear in the sound era was designed by
Robert Cawkwell, working with assistance from consultants at RCA Sound. The Paragon, owned by
Paragon Picture House (Sheffield) Ltd, seated 1,386, with 1,034 in the stalls and 352 in the balcony,
and opened on 1 October 1934 with *Bottoms Up*. The proscenium opening was 40 feet wide and
cinema furnishings specialist Kenneth Friese-Greene was called upon for most of the interior design
work. The first CinemaScope film to be shown at the Paragon was *The High and the Mighty* in
February 1955. Never opening on Sundays, the Paragon's final film was *Parish*, shown on Wednesday
28 February. It was then demolished. The picture shows a Christmas party at the Paragon.

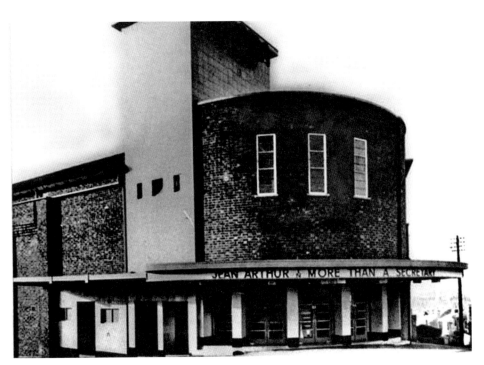

Above and below: **Handsworth, Plaza, junction Richmond Road/Bramley Lane/Bramley Drive**
Designed by Bernard Powell and built by W. Malthouse Ltd, the Plaza opened on 27 December 1937 with over 1,100 seats. Controlled by Plaza (Sheffield) Ltd, the first film to be shown was *The Plainsman*. The cinema was refurbished in 1947, introduced CinemaScope in 1955 (with *Three Coins in a Fountain*), redecorated in 1962 and introduced live entertainment into the weekly programme in 1963. Closure came on 29 September 1963 and the building has since housed a bingo hall, and then a bowling alley. The bottom picture was taken on 7 August 2011.

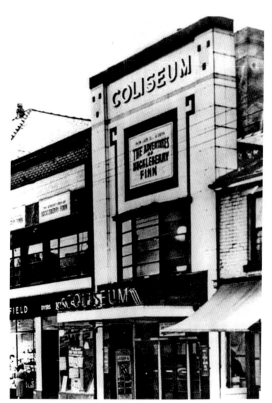
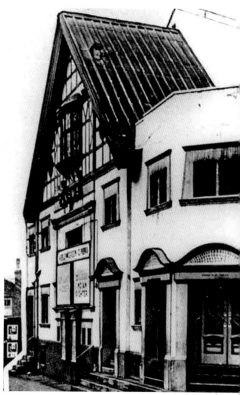

Above left: **Heeley, Coliseum, London Road**

The Coliseum, with a slim, white faience frontage, was opened by Heeley Coliseum Ltd on 27 October 1913. Designed by W. H. Lancashire & Sons, the auditorium seated about 600. Sound came with *Whoopee* on 3 August 1931. Four years later it was redeveloped by George Longden & Sons Ltd, seating was increased in the balcony, and a new proscenium was added in 1939. Films in CinemaScope started in May 1956. The Coliseum closed on 14 January 1961 after showing *The Three Musketeers* and was demolished.

Above right: **Heeley Green Picture House**

Built with a half-timbered gable frontage by M. J. Gleeson, the Heeley Green Picture House opened on Easter Monday, 5 April 1920. From April 1929 its main usage was for vaudeville and variety, with seating in stalls and circle levels for about 1,000, becoming known as the Heeley Green Theatre. It came back into use as a cinema from May 1938. The premises closed on 7 March 1959, only to reopen again on 3 April 1961 as the Tudor Cinema. Closure came once more on 14 July 1962, and the building was used thereafter for bingo and snooker until it was badly damaged by fire in June 2004.

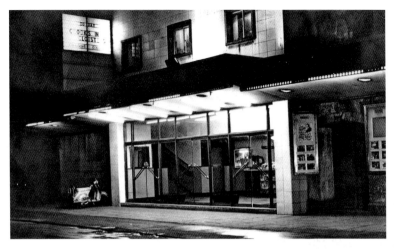

Hillsborough, Kinema House, Crookes Place (later Proctor Place)

The Kinema House, which was designed by Benton & Roberts, opened in November 1912 with seating for about 850, including 150 in the balcony. This was increased to approx. 1,150 following alterations in 1920. The first talkie was shown on 2 December 1929: *Broadway Melody*. Architects Hadfield & Caukwell considerably altered both the exterior and interior of the building in 1935, including increasing the seating to approx 1,200. Bomb damage caused the cinema to close between December 1940 and October 1941. The final film at the Kinema House was on Saturday 23 July 1966, and then the building was demolished.

Hillsborough Park Cinema

The Hillsborough Park Cinema opened on Thursday 10 February 1921. It was built in red brick with a white faience façade and seated 1,300 (900 in the stalls and 400 in the circle). Sound came in April 1930, and a year later the cinema was entirely redecorated. The Park was taken over by the Star Cinema Group in February 1960 and a modernisation programme was carried out. Sunday opening and a Saturday Star Juniors Club were also reintroduced. A double 'X' certificate programme, *Dr Crippen* and *Buckets of Blood*, closed the Hillsborough Park Cinema on Sunday 29 October 1967. Later, it reopened as a Star Bingo Club; the building currently survives as a supermarket. The photograph was taken on 7 August 2011.

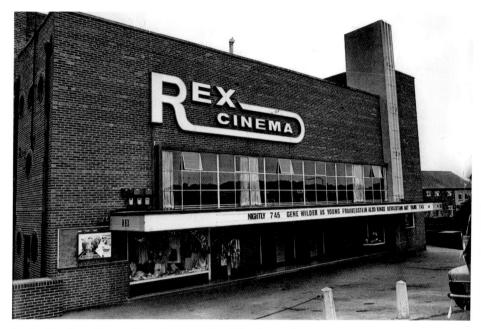

Intake, The Rex Cinema, Mansfield Road/Hollybank Road junction
Largely faced with rustic bricks and featuring a blue tiled tower, the Rex cinema was designed by Hadfield & Cawkwell and opened on 24 July 1939. Seating 1,350, it was owned and managed by Miss Dorothy Ward and opened with *Men with Wings*. *Rose Marie* was the first CinemaScope film shown in March 1955. Closure came on 23 December 1982 with *Chariots of Fire* and *Gregory's Girl*. The building was demolished a year later.

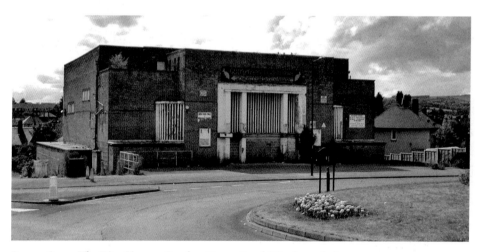

Parson Cross, The Ritz Cinema, Southey Green Road/Wordsworth Avenue
Built by W. G. Robinson Ltd to the designs of Hadfield & Cawkwell, the Ritz was opened to the public on Monday 6 December 1937 with *Pennies from Heaven*. Initially owned by Ritz Picture House (Sheffield) Ltd, it was taken over by the Star Group in 1961. The programme fluctuated between bingo and films from 1962. Closure as a cinema came five years later on 9 November; the last film shown was *The Amorous Adventures of Moll Flanders*. Full-time bingo then followed until about 2001.

Stocksbridge Palace, Manchester Road

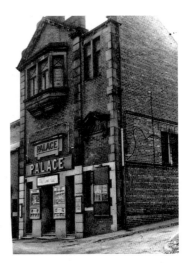

Opening on 12 May 1921 with *Kismet*, the Stocksbridge Palace seated around 1,000, including 300 in the circle. The first talkie shown there was *Let us Be Gay* on 4 August 1931. At one time variety acts appeared at the Palace, and Reginald Dixon was a former resident musician. The Palace was taken over by the Star Group in 1942; CinemaScope was introduced in November 1955 and a flirtation with bingo sessions on certain days started from 1962. Closure came on 23 July 1966, and thereafter the building became a bingo hall.

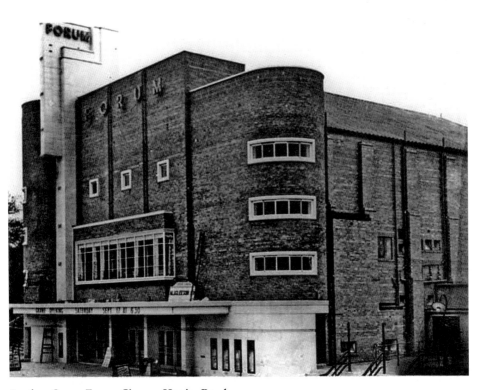

Southey Green, Forum Cinema, Herries Road

Opening on 17 September 1938 with *One Night of Love*, the Forum was built for Forum Cinema (Sheffield) Ltd by Gleesons to the designs of George Coles. The auditorium seated 1,814, and the cinema became part of the Essoldo group in April 1955. At the same time, the company introduced CinemaScope and a stereo sound system was installed. Just over a year later it became the Essoldo Southey Green, and between December 1961 and May 1962 bingo was featured one night each week. Final closure as a cinema came on 31 May 1969 with *Bullitt* and *One Silver Dollar*. Existing as bingo hall for a short period afterwards, it was eventually demolished and a supermarket occupies the former site.

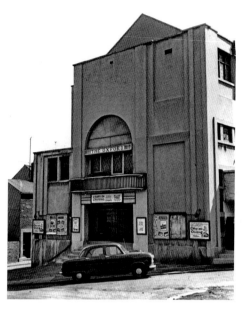

The Oxford Picture Palace, Addy Street, Upperthorpe

The Oxford Picture Palace was opened in a converted Unitarian chapel on 15 December 1913. The design work was carried out by Hickton & Farmer and the cinema seated about 900. In 1920 the Oxford became part of Heeley & Amalgamated Cinemas, and was taken over by the Star Group in January 1955. The Oxford survived until 15 August 1964; the final films were *Two Way Stretch* and *I'm Alright Jack*. Later, the building was demolished.

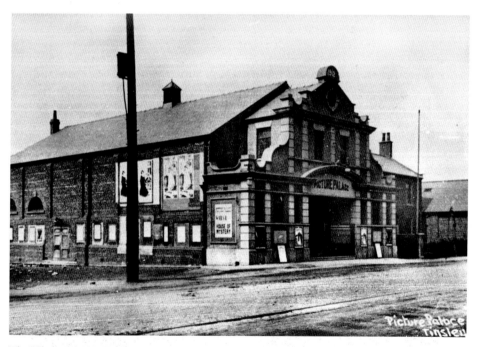

The Tinsley Picture Palace

The Tinsley Picture Palace was opened on 16 November 1912, seated 600 (all on a single floor), and the first film was *The Siege of Petersburg*. From 1919 it was owned by the Wincobank Picture Palace Company, and a year later alterations were made to the façade, raising the building to three storeys in height. Also, a balcony was constructed inside the auditorium, seating a further 150. Sound was installed by 21 April 1930, CinemaScope by March 1955. The Tinsley Picture Palace closed on 15 February 1958 with the films *Dry Rot* and *Dual at Apache Wells*.

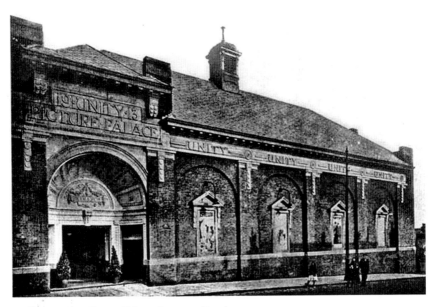

Walkley, Unity Picture Palace, Langsett Road

Built by George Longden & Sons Ltd and designed, with an impressive entrance arch, by J. Amory of local firm Gibbs, Flockton & Teather, the Unity Picture Palace opened on 7 November 1913. Operated by the Upperthorpe Picture Palace (Sheffield) Ltd, the Unity accommodated 990 (including the balcony) and among the managers were Harry Bramwell (1913–1934) and Frank Neal (194-1956). The last films were *Oregon Passage* and *Destination 60,000*, on Saturday 28 March 1959. Later, the building was used as a furniture showroom.

Picture Palace, Merton Lane, Wincobank

The Wincobank Picture Palace, with seating for 550, opened on 11 June 1914. A small balcony was installed in 1926, adding seating for an additional 100 patrons.

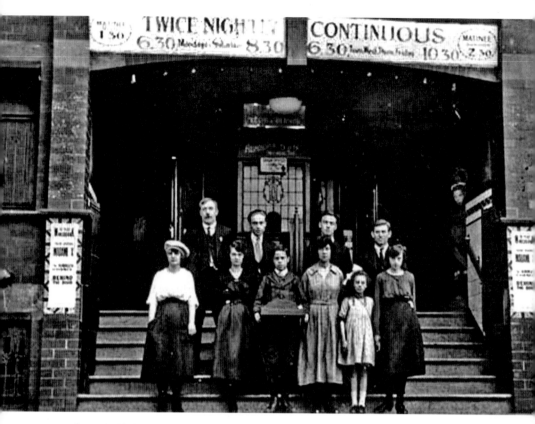

Above and below: A Western Electric sound system was installed at the Picture Palace by April 1930 and further improvements were undertaken in 1946, 1953, and 1955, when CinemaScope was introduced. The Picture Palace closed on 21 February 1959.

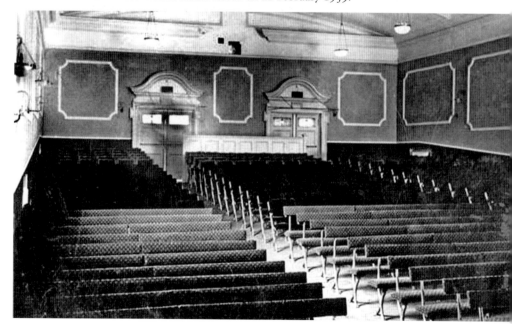

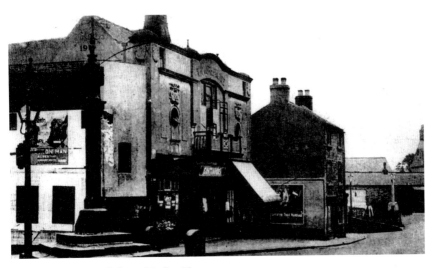

Woodhouse Picture Palace, Market Place

Curiously featuring a 'balcony' above the front entrance, the Woodhouse Picture Palace opened on 2 March 1914 with seating for about 600. In the first few years of existence live theatre was part of the programme of events. Seating was increased by 120 in 1920, sound was introduced ten years later, a building refurbishment took place in 1937 and CinemaScope was installed by July 1955. Harold Booth was the Picture Palace manager from 1926 until closure on 28 December 1957.

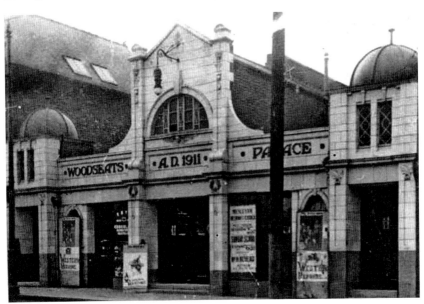

Woodseats Palace, Chesterfield Road

Opening on Monday 4 September 1911, the Woodseats Palace was designed and built by W & A. Forsdike Ltd and featured a white glazed frontage incorporating two domes. Seating a mere 550 people, the Palace also had a small stage and the opening programme included seven short films. A balcony incorporated in 1920 added height to the building and increased the seating by another 250. A Western Electric sound system was installed in the 1930s.

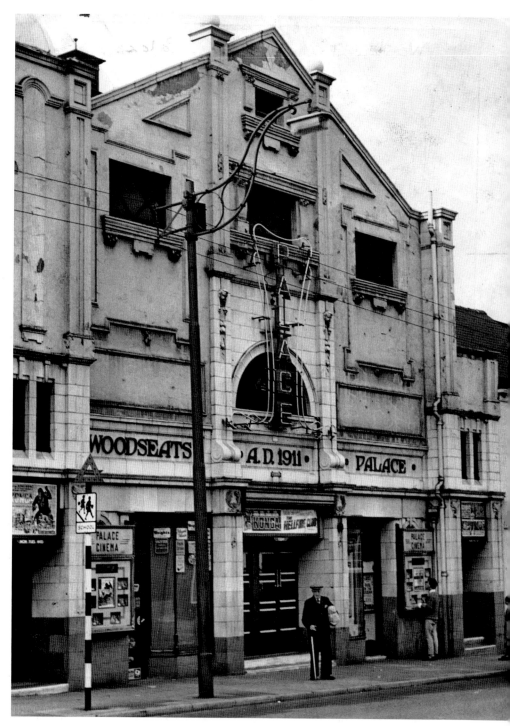

By January 1955, the Palace had been absorbed by the Star Group and CinemaScope was introduced shortly afterwards. The final films, shown on 24 September 1961, were *Slaughter on 10th Avenue* and *Taming Sutton's Girl*. Later, the building was converted to a store and occupied by Fine Fare, Kwik Save and Alldays, but is currently a Wetherspoon's pub called the Palace.